IMAGES
of America

SOUTH HADLEY

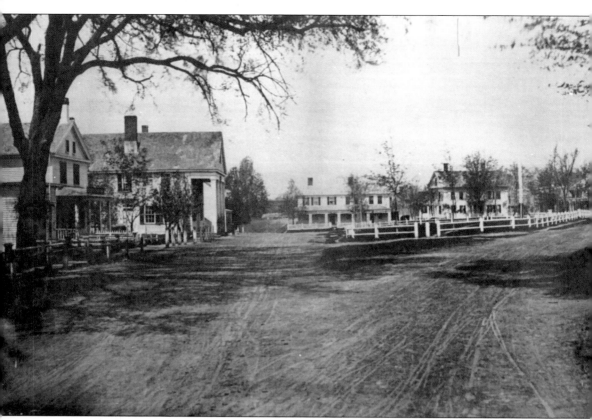

This was the town common as it appeared about 1850. The two large buildings to the left were Gridley's general store and Houghton's Mount Holyoke Hotel. They both were burned in the 1876 fire that destroyed a number of other buildings. At the far end is Miller's Tavern, the first meetinghouse, which had been moved north of the town common, and G.A. Smith's house.

IMAGES of America

SOUTH HADLEY

Irene Cronin and the
South Hadley Historical Society

ARCADIA
PUBLISHING

Published by Arcadia Publishing
Charleston SC, Chicago IL, Portsmouth NH, San Francisco CA

Printed in the United States of America

Library of Congress Catalog Card Number: 98-87330

For all general information contact Arcadia Publishing at:
Telephone 843-853-2070
Fax 843-853-0044
E-Mail sales@arcadiapublishing.com
For customer service and orders:
Toll-Free 1-888-313-2665

Visit us on the Internet at www.arcadiapublishing.com

CONTENTS

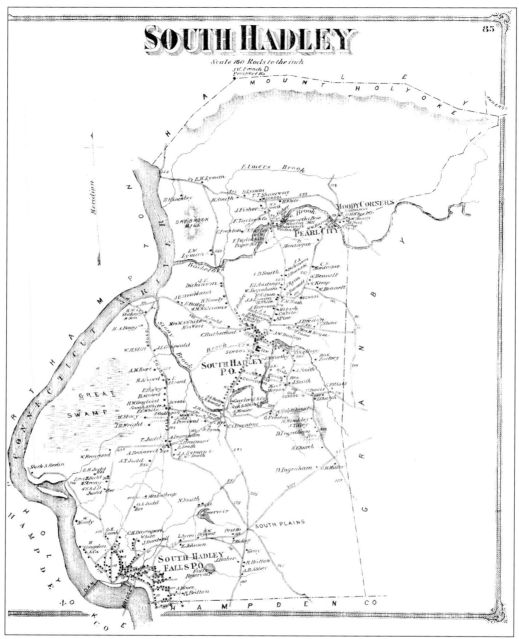

This is a map of South Hadley c. 1853

INTRODUCTION

South Hadley originally was part of Hadley. As the population of Hadley grew, the young people requested that land south of the Mount Holyoke range be made available for settlement. The first grant was made in February 1675 to Thomas Selden. Other grants followed and, as the settlement grew, the settlers wanted to have their own place to worship and requested that the settlement be made a precinct of Hadley. After presenting three petitions, they were able to meet the requirement that a minister be settled and a meetinghouse built. Grindall Rawson, a Harvard graduate, was ordained as the minister on October 2, 1733, and the first meetinghouse was erected on "Sandy Hill," now the town common.

As the settlement continued to expand, the desire for more self-governing power increased, and a petition was made to make South Hadley a district. The General Court granted the request in 1753 giving South Hadley all the powers of a town except the right to choose a representative to the General Court. It could join several other districts to choose only one representative. The first meeting of the South Hadley district was held in the meetinghouse on April 30, 1753. With the coming of the American Revolution, South Hadley obtained all the powers of a town.

Through the years South Hadley has gone through many changes. An important event was the building of the first commercial navigable canal in the United States which was constructed to bypass the falls that were an obstacle to navigation. There was a 53-foot drop along a 2.5-mile stretch of the river. Previously, cargoes had to be unloaded from boats, carted around the falls, and reloaded above the falls onto other boats, an arduous and time-consuming task. An inclined plane was built to lift the flat boats above the falls and float them into the canal which took them past the rapids.

The canal was opened to traffic in April 1795. Locks were substituted for the inclined plane and completed in 1805. Transportation along the Connecticut River was greatly facilitated and increased, and South Hadley became a busy shipping center. With the building of railroads in the mid-1800s, river transportation was replaced by rail transportation, which ran all year and was more reliable.

Mills were built along the rivers and streams. Businesses came and went. The population continued to increase, bringing with it new needs. Farming became an important part of life.

Another significant event in South Hadley history was the building of the County Bridge in 1872 that replaced the ferries and greatly facilitated transportation and commerce between South Hadley, Holyoke, and the surrounding area. The founding of Mount Holyoke

College by Mary Lyon in 1837 and the advent of electrification in the late 1880s were also important developments.

Through this selection of photographs, we tried, with brief annotations, to provide an overview of events, people, and places in South Hadley from its beginning to 1970. Unfortunately, we were unable to obtain photographs of some people, businesses, and buildings important to the town's history.

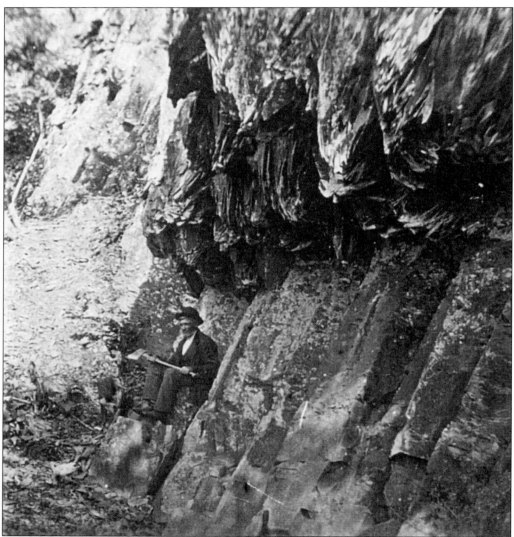

One of the world's natural phenomena are Titan's Pier and Titan's Piazza. They are volcanic bluffs of columnar formation created by volcanic action during the Mesozoic Age when the molten lava cooled and cracked into columns as it contracted. Titan's Pier is located on the South Hadley side of the Connecticut River opposite Mount Tom Junction. Titan's Piazza is east of the road leading to the Mount Holyoke Summit House.

One

EARLY SOUTH HADLEY

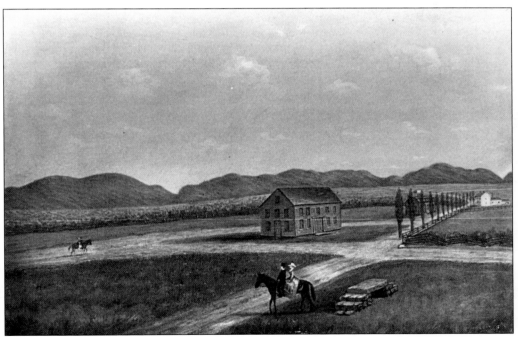

The first meetinghouse was built in 1733. As the town's population grew, the seating capacity became inadequate, and it was sold to John Chandler, who moved it to its present site north of the common in 1764. The original site is marked by a drinking fountain. The house has had several additions and served various purposes over the years. It is now Woodbridge's restaurant.

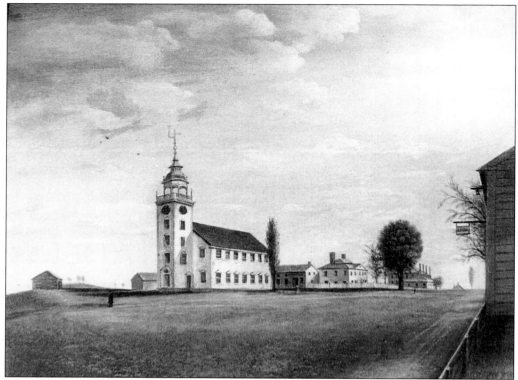

After much controversy as to where to locate it, the second meetinghouse (painting by Joseph Chandler) was built near the site of the present First Congregational Church and was finished between 1763 and 1764. In 1791, Colonel Ruggles Woodbridge offered to donate a church bell. A belfry and steeple were built for it. The need for a larger church developed, and in 1844 the second meetinghouse was razed.

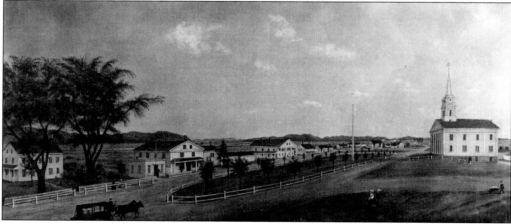

The third meetinghouse (painting by Joseph Chandler), known as the White Church, replaced the second one in 1844. In appreciation of its being used by the Mount Holyoke Female Seminary students and staff, Mary Lyon donated a large pulpit Bible. When the church was destroyed by fire on January 17, 1875, Joseph Clark rushed in and saved the Bible and other church property. Mary Lyon's funeral was held in this church in March 1849.

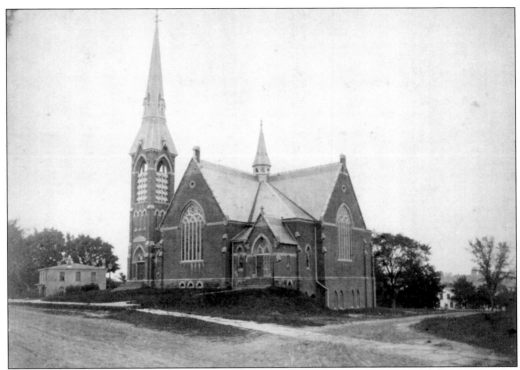

This brick church was built to replace the third meetinghouse. On March 4, 1894, it was also destroyed by fire, probably caused by an overheated furnace pipe. The Mary Lyon Bible was saved again, this time by Charles Spooner.

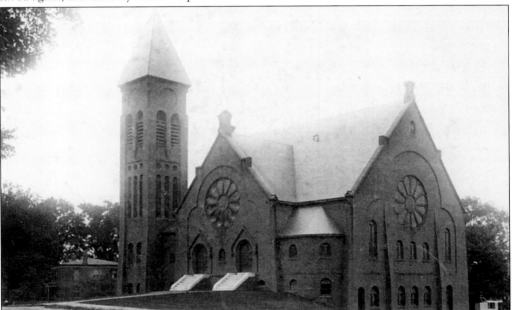

This First Congregational Church building replaced the one that burned in 1894. It was dedicated on January 16, 1895.

The old "Brick Chapel" was built about 1815 on North Main Street on a site furnished by Ariel Cooley. The Methodists, Congregationalists, and Baptists all held their services here, sharing the expenses for its upkeep. The building became too small and the denominations went on to build their own individual churches.

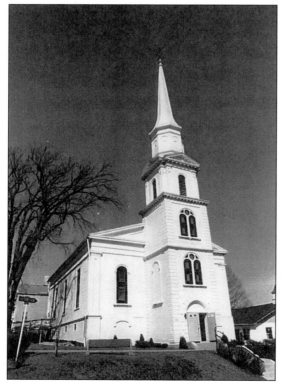

The Methodist Church was organized in 1827 and met in the Brick Chapel until they built a two-story brick building in 1832 at what is now 8 Gaylord Street. In 1880, the Methodists bought the former Congregational church building at the corner of North Main and Carew Streets, and have used it to the present.

The Congregational Church of South Hadley Falls was donated by Deacon Joseph Carew and his wife in 1864 and was located on North Main Street. The Congregational Church traces back to February 1824 with the formation of the South Religious Society and an organization of a church of 19 members. In 1834, they built the church on Gaylord Street which they later sold to the Methodist congregation.

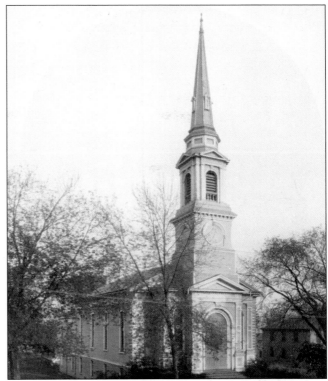

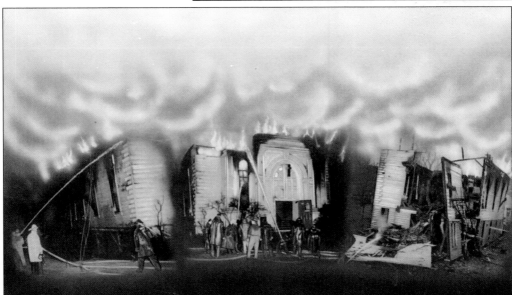

The Congregational Church of South Hadley Falls was completely destroyed by fire on April 22, 1947. The picture is a composite to show the sides collapsing. The present red brick edifice of colonial design was built on the same site. It was dedicated on October 30, 1949, and has been serving an ever-growing parish.(Courtesy of the Congregational Church of South Hadley Falls.)

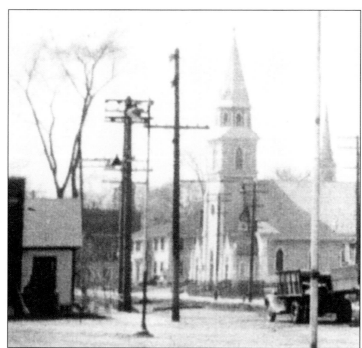

Saint Patrick's Church, the town's first Roman Catholic institution, was established in 1867 on North Main Street as a mission of Holyoke's Saint Jerome Church. In 1877, it was made a separate parish. In 1892, the church was moved to its present location on Main Street.

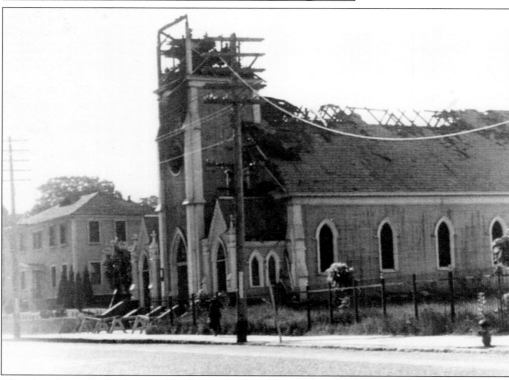

The church was badly damaged by fire in 1938 and had to be rebuilt. It was also damaged by the 1936 flood and 1938 hurricane.

Two

BUSINESS AND INDUSTRY

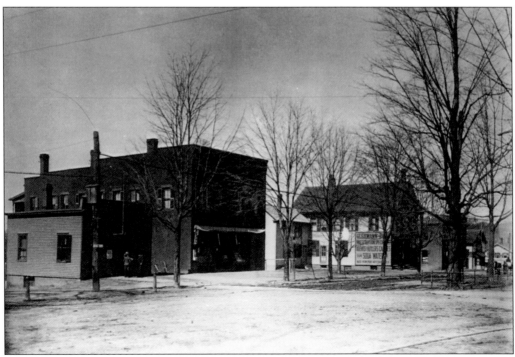

In this 1910 photograph, the buildings on College Street to the left of the town common were: the small wooden post office, Gridley's store, an apartment house owned by Frederick Kirby, Glesmann's Pharmacy (with the sign on the side), and beyond that were the building housing Felice's shoe repair shop and C.E. Spooner's meat market.

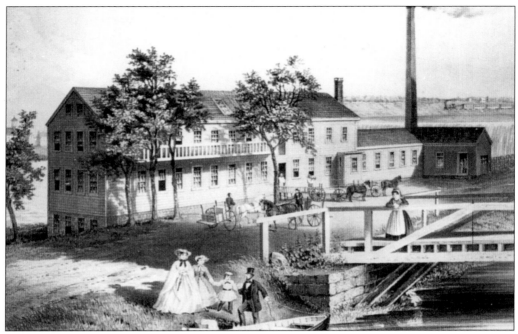

This photograph of the Carew Manufacturing Company overlooks the South Hadley Canal facing the Holyoke dam and Holyoke. It shows the building as it first appeared in 1848. The wooden building burned in 1873 and was replaced by a brick one. The clothing worn by the people reflects mid-19th-century styles.

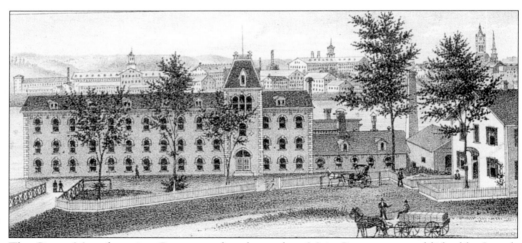

The Carew Manufacturing Company, then located on Main Street, was established by Joseph Carew in 1848 to produce fine writing paper. In 1873, the Carew mill burned down and was replaced by a more costly three-story brick structure with marble facings and trimmings. After Carew's death the company went through several reorganizations.

The Hampshire Paper Mill, viewed from the Holyoke side of Connecticut River, was built by the Glasgow Company about 1863 and sold in 1866 to the Hampshire Paper Company. It produced high-grade papers, especially Old Hampshire bond, which remained famous until about 1935. The Carew Manufacturing Company carried on production of Old Hampshire bond until 1940, when the Stevens Paper Mills took over the Hampshire Paper Company.

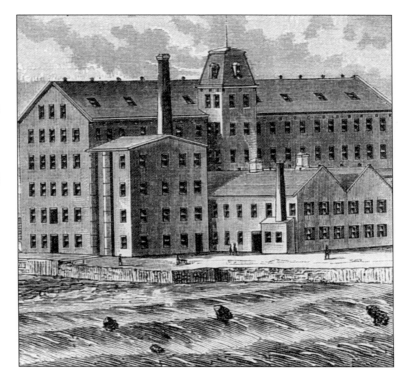

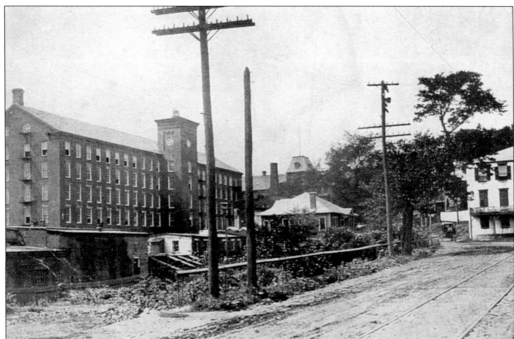

In 1903, the Hadley Mills took over the old Glasgow Company and continued to produce textiles. About 1930, the Hadley Mills went into bankruptcy. The Holyoke Water Power Company bought the property.

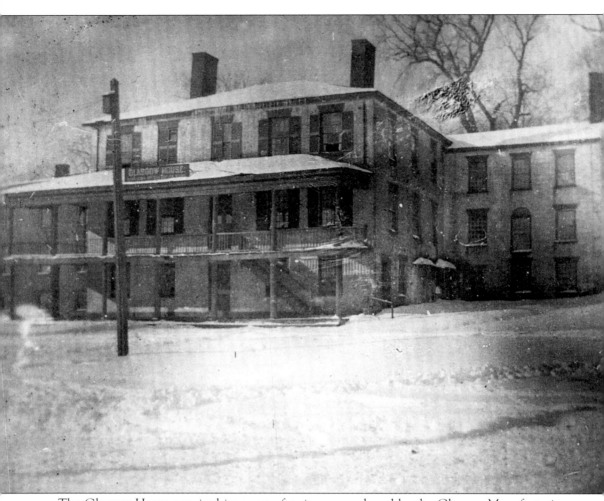

The Glasgow House acquired its name after it was purchased by the Glasgow Manufacturing Company in 1848. Before that it was called the Canal Tavern and was built probably by Ariel Cooley before 1806 to serve the riverboat men. There was a store on the ground floor. The tavern became primarily a boardinghouse and restaurant serving the mill workers. After the Hadley Mills took over the Glasgow Company, it was called the Hadley House. The Holyoke Water Power Company bought the property and demolished the old tavern building in 1931.

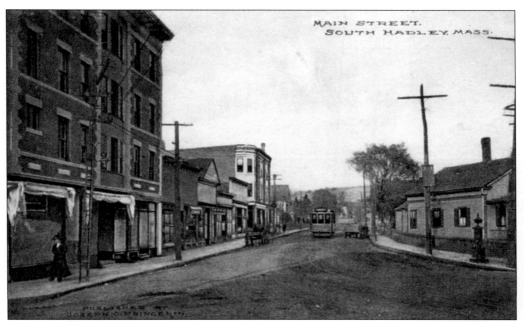

The view depicted here on a postcard is improperly labeled "Main Street." It is actually a view of Bridge Street, early 1900s, as seen when entering South Hadley from the Old County Bridge.

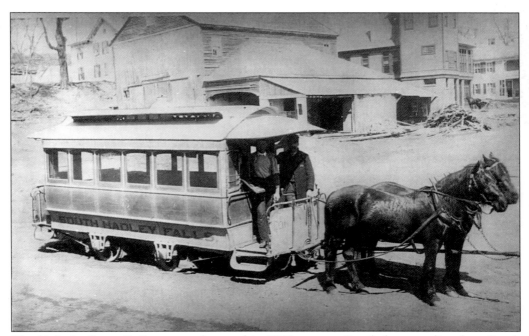

The Holyoke Street Railway was chartered in 1884 to run a 2-mile horsecar line from South and Main Streets in Holyoke to North Main Street in South Hadley, where there were horse barns. The line was extended to 6 miles, and in 1891 the system was electrified and the horse cars replaced by trolleys.

The Arcade Building was a landmark on Main Street for much of the 20th century. It was located next to where the Haas Electric Company building now stands. The building was erected about 1908, and derived its name from the passageway in the middle of the ground floor that was used to reach two houses in back of the building. There were four stores on the ground floor and eight six-room apartments on the two upper floors. Among the businesses that occupied the stores over the years were a barber shop, an A&P grocery store, bakeries, beauty shops, an insurance agency, a dance studio, laundry, plumber, and electrician.

The building lost its handsome appearance after a decade or two when the outer walls and decorative balustrades were covered with fake brick shingles. The 1936 flood washed away the storefronts and interiors. The stores were rebuilt but the building continued to deteriorate, became structurally unsound, and was demolished in 1974.

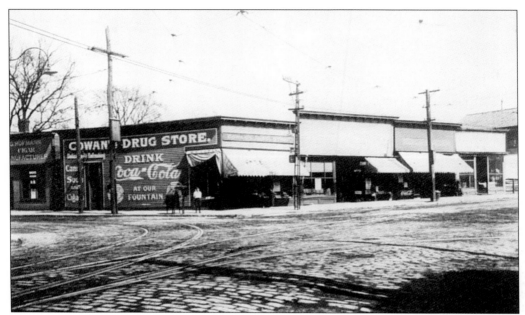

The Cowan Block at the corner of Main and Bridge Streets originally was a one-story wooden building that housed several stores. Willie Cowan rented the corner store in 1903 and ran the drugstore until he retired in 1946. The wooden building was replaced by a four-story brick building around 1915. It was owned by Jacob Solin and was called the Solin Block at first and then the Cowan Block.

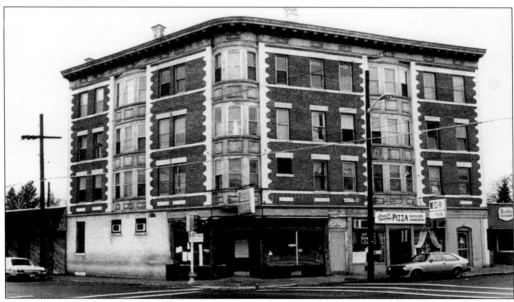

Cowan's Drug Store, c. 1940, also housed the "Falls branch" of the Holyoke Post Office and served for a number of years as agent for the Springfield Gas Light Company, New England Telephone, and Telegraph Company. After Cowan retired, Sammy Watson and then George Jessop operated the drugstore until about 1982. The building deteriorated and was being renovated when it burned on December 3, 1992 and was razed.

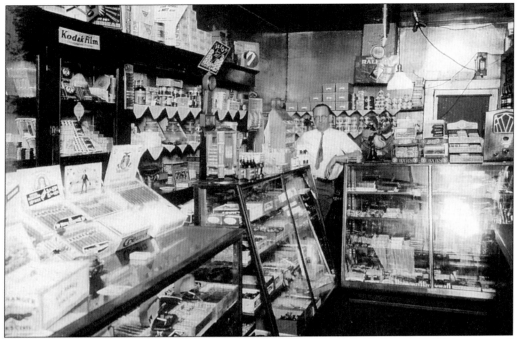

William Schiffner is shown in the newsroom he and his wife Anna started in 1924 in a small building at 8 Main Street near Dietel's drugstore. They sold newspapers, magazines, candy, cigars as well as cigarettes, milk, bread, and some canned goods. The 1936 flood destroyed the building so they bought property at 4 Bardwell Street and built a brick building where they expanded the number of items they sold.

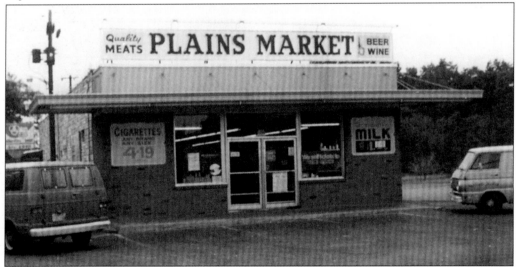

The Plains Market, then located on the northwest corner of the Granby Road at Lyman Street, was once a neighborhood fixture. It was built in 1947 by Joseph Koske who operated it until 1964 when he sold it to George and Barbara Vaughn. They ran it very successfully until 1974 when, through eminent domain, the property was taken by the state Department of Public Works to widen the highway.

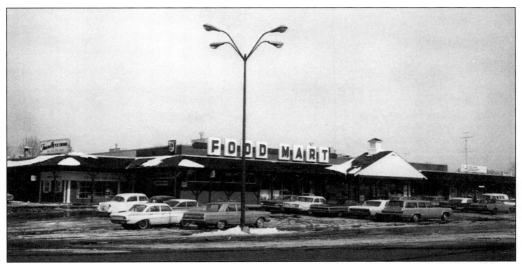

The Interstate Development Corporation of Hartford built the Food Mart Plaza off Newton Street at Lyman Street. The formal opening took place on May 19, 1965. Waldbaum's Food Mart, Friendly's, General Cleaners, and Woodlawn Pharmacy were the major stores, but several small businesses came and went. There have been some major changes and expansions recently. (Courtesy of Mount Holyoke College Archives and Special Collections.)

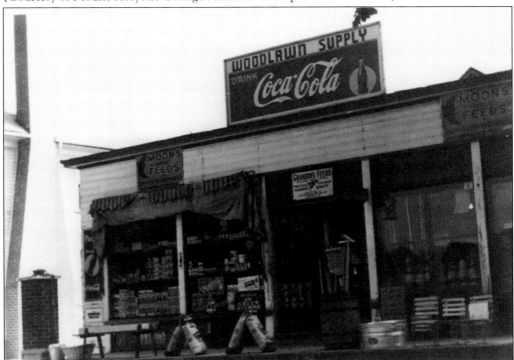

The Woodlawn Supply Company was a fixture in the Woodlawn area from 1925 until 1964. It was located at the front of what is now the Food Mart Plaza on Newton Street. Charles and Carl Tittemore owned the store until 1936 when Daniel B. Ducharme bought it. The store carried a little of everything. (Courtesy of Dan Ducharme.)

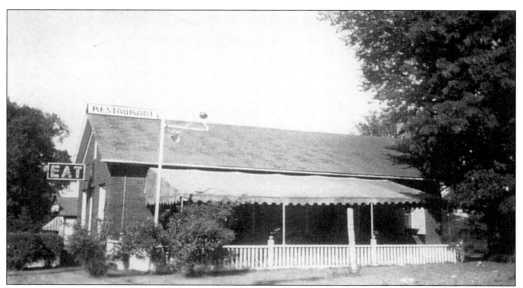

Mary Kay's Restaurant at 9 Woodbridge Street was one in a succession of restaurants at that address for 30 years. Mary K. Ryan rented and ran the restaurant from 1937 to 1942. It was frequented by college students and local residents. Kay moved to Hartford in 1942 and the restaurant was run by several people under different names until Mount Holyoke College bought the property in 1959 and razed the restaurant.

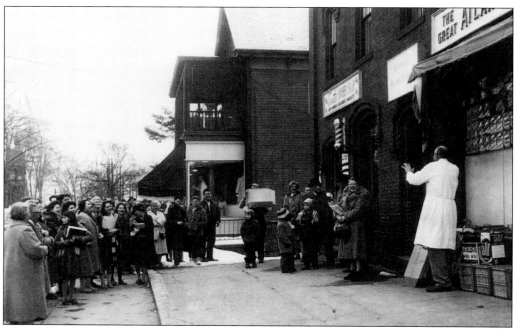

The small A&P grocery store opposite the town common served the people in South Hadley Center for over 33 years. It opened around 1928 and was run by Charles Ball and Ed Bunyan. They were well-liked by their customers, who protested the store's closing and gave them a royal sendoff.

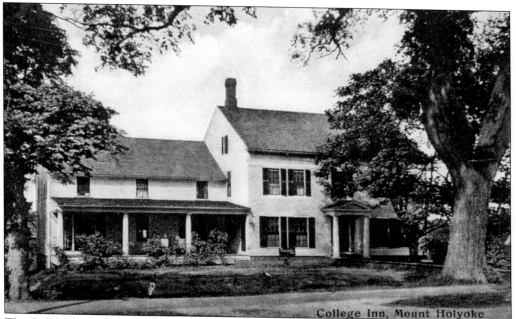

College Inn, Mount Holyoke

The College Inn was built in 1783 for Reverend Joel Hayes. Alice Little, a 1903 Mount Holyoke College graduate, ran an inn there until 1940 when she sold it to Howard Keyes. The inn was a popular hangout for college students and town residents. In 1962 Keyes sold it to Mount Holyoke College who rented it to Romeo Grenier for 25 years. The inn was destroyed by fire in 1985. (Courtesy of Mount Holyoke College Archives and Special Collections.)

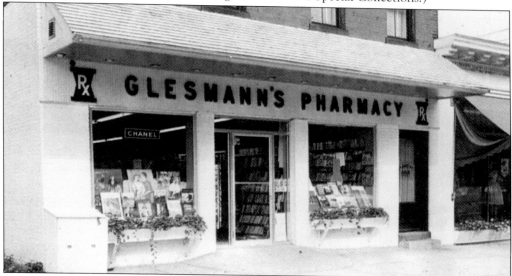

For years Glesmann's drugstore, Glessie's, was a town institution, popular with students and townspeople. It was opened in 1903 by Robert Glesmann and his brother August, in a frame building opposite the town common. In 1927, it was moved into the former Gridley brick building two doors up. Romeo Grenier took over in 1957 after Glesmann retired and John B. Cannon took over about 1970. The building was destroyed by fire in 1981. (Courtesy of Mount Holyoke College Archives and Special Collections.)

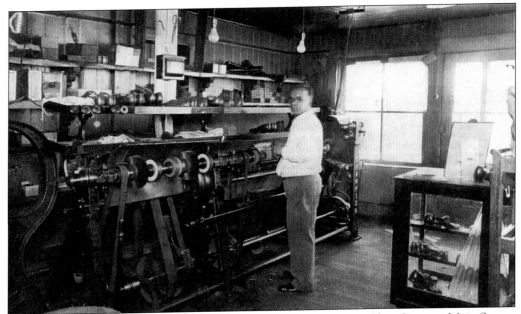

Richard Boerner stands at the shoe repairing machinery in Boerner's Shoe Store on Main Street. The business was established by Ernest Boerner in 1906 and his sons Richard and William worked for him. They sold new shoes and repaired old pairs, as well. The store was destroyed in the 1936 flood. Ernest retired; his sons transferred the business (Boerner Brothers) to a store at 30 1/2 Bridge Street. (Courtesy of Helen Marten Hamel.)

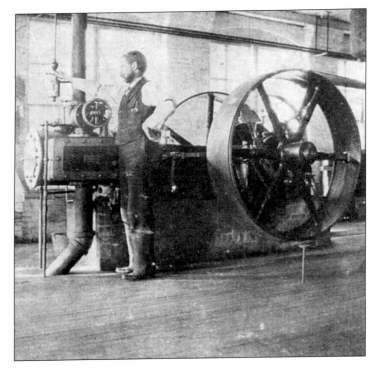

This was the Ball and Wood generator at the South Hadley Falls Electric Light Company. The company was established in 1888 under private management and was located in rented quarters at the Glasgow Manufacturing Company on Main Street. Then the Electric Light Company moved to the Hadley Mills when it took over the Glasgow Company. The town purchased the South Hadley Electric Light Company and officially took possession of the plant in 1914.

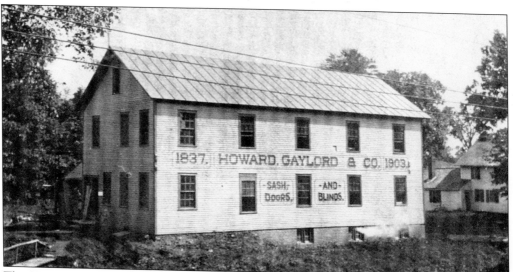

The Howard, Gaylord and Company sash and blind factory was located on the lower falls of Stony Brook off College Street. The property was acquired from Peter Allen in 1834 by John Hastings and Alonzo Cutler, who owned patents for sash-making machinery. They erected buildings and began making sash tools and sashes. There were a few changes in ownership and in 1853 the business was sold to Eleazar Howard and Moses Gaylord. They and their descendants operated the business. (*Know Your Town Calendar.*)

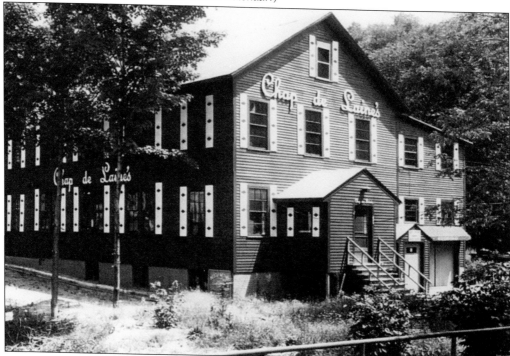

The Howard, Gaylord and Company building was remodeled by Chap de Laine's Interiors in 1963, and is currently used for a furniture store as well as an interior decorating business. (Courtesy of William Chapdelaine.)

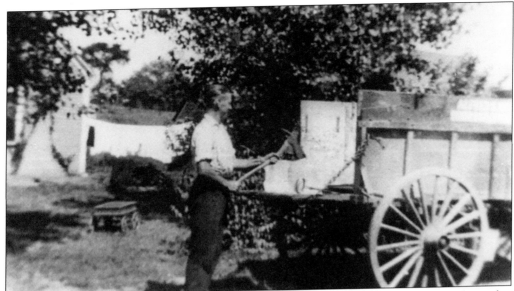

John Moody, son of Alfred S. Moody, is shown chopping ice in 1918. Alfred S. Moody ran his ice company from about 1907 to 1936. He later named it the South Hadley Falls Ice Company. His office and icehouse were located on Canal Street and he cut his ice from the Connecticut River. He also was a wholesaler for other distributors.

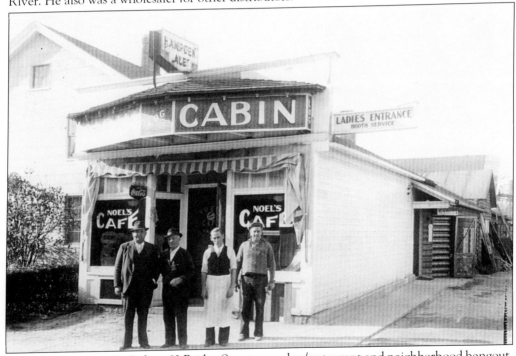

The Log Cabin Noel's Cafe at 60 Bridge Street was a bar/restaurant and neighborhood hangout. Edgar R. Noel ran it from 1935 until his death in 1944. Carl A. Baker bought it, remodeled it, and ran it as Carl Baker's Log Cabin. The business changed hands and was remodeled a few times. It is now called Ebenezer's and is still a neighborhood hangout.

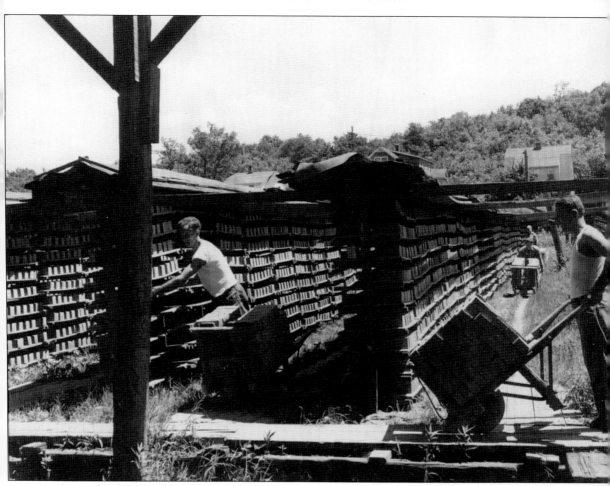

Men wheel finished bricks to the curing sheds at the Lynch Brickyard off Lamb Street. A large clay deposit between Lamb Street and Tannery Road provided raw material for making bricks. During the last decades of the 19th century and early 20th century, brickmaking was South Hadley's second major industry. Much of the brick for Holyoke's mills and blocks came from the Lynch Brickyard that Maurice Lynch and his brothers established in 1880.

The Robillard grocery store at 25 South Street was one of the many small grocery stores serving their neighborhoods. Zenon Robillard bought the house with the small attached store in 1925 from Exilda and Rene Plouffe. Robillard operated the store until his death in 1954. His son Paul ran it for a few years, and then rented it until 1965, during which time it was a package store. It was later demolished. (Courtesy of Paul Robillard.)

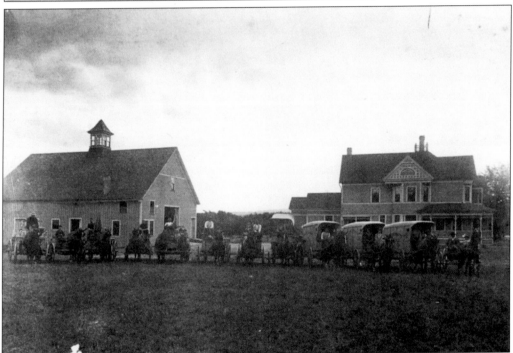

Charles Lawrence Independent Ice Company wagons, horses, and drivers stand to the side of Lawrence's barn and residence on the Granby Road about 1908. Lawrence came to South Hadley in 1897 and bought a property lot that included a pond and icehouse. Ice was cut from the pond which was called Lawrence Pond at first, then Hillside Beach Pond. He became one of South Hadley's biggest ice dealers.

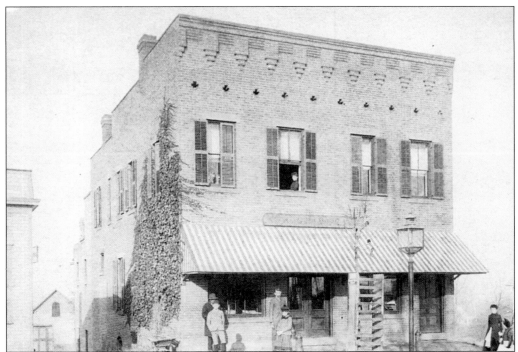

Charles Gridley's general store on College Street opposite the town common was a town fixture for many years. It carried groceries, hardware, dry goods, notions, candies, stationery, jewelry, and other products. The store was destroyed in an 1876 fire but was rebuilt. Gridley retired in 1913. His son-in-law, George Canney, continued to run the store until 1927 when Robert Glesmann purchased it and moved his drugstore into the building. (Courtesy of David Canney.)

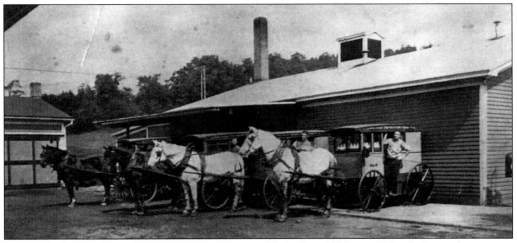

The Holyoke Producers Dairy Company was established in 1921 at 12 North Street by a group of area farmers to produce the best milk possible and assure a stable market for their products. In 1928, the company moved to Holyoke and in 1944 became part of H.P. Hood and Sons. The North Street property was sold to the town and used as the town yard until 1973. The site later became the North Street Playground.

Cow Barns

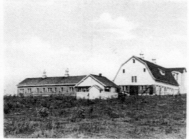
Rear of Farm Buildings

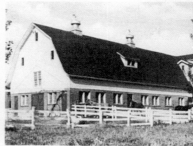
Cow Barn and Paddocks

"BONNIELEA FARM"

Spreading out over 114 acres of almost all tillable land, "Bonnielea Farm" has been designed and equipped as a model producing dairy farm. Its location at South Hadley, Massachusetts, is extremely convenient and accessible, being only three miles from the railroad station, schools and shopping center of Holyoke, ten miles from Springfield.

The natural qualities of this farm, as well as its improvements and equipment, offer every opportunity for very profitable operation. Water is available for all fields and pastures from two ponds and two streams, and the land is sufficiently sloped for excellent drainage. The tillability of practically all the acreage, which consists of heavy rich loam, allows

for crop and pasture rotation under ideal conditions. The entire property is sturdily fenced, chiefly with posts of reinforced concrete.

Approached through picturesque stone gate posts and surrounded by about an acre of ground, landscaped with tall shade trees, shrubs,

Farm Residence

flower and vegetable gardens is the main farm residence, built in 19[...] 1942. It is an attractive Cape Cod Colonial of frame constructi[...] with seven rooms and bath, completely improved and very moder[...] appointed. Several of the main rooms are panelled in knotty pine, [...] kitchen is electrically equipped, and the bath tiled. Its very convenie[...] size and arrangement present no housekeeping problems. There is [...] four-car detached garage and a tenant house of five rooms and ba[...]

The farm buildings are outstanding, for they are all of brick c[...] struction and equipped with electricity, slate and asphalt shingle roo[...] and concrete floors. (A list of these buildings will be found on [...] back page of this brochure.) Included with the property is complete dairy and farming equipment and machinery, in addition to a fine herd of sixty fancy grade cows, which yield 500-600 quarts of Grade A milk per day. Other livestock includes two bulls and two young horses.

Living Room

This is the brochure in which Arthur L. Donnellan offered his farm, Bonnielea, on Alvord

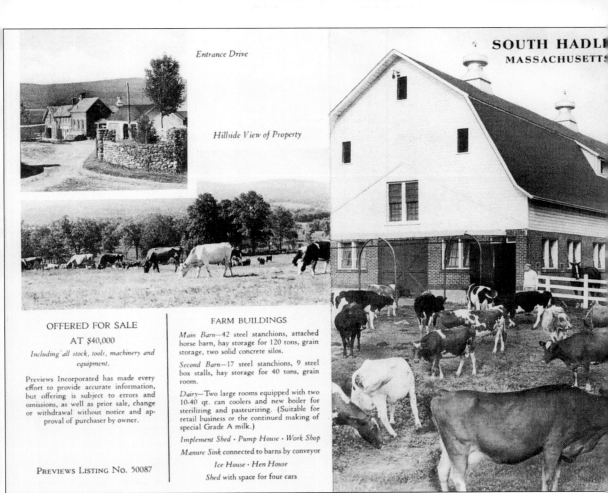

Entrance Drive

Hillside View of Property

SOUTH HADLE
MASSACHUSETTS

OFFERED FOR SALE
AT $40,000

Including all stock, tools, machinery and equipment.

Previews Incorporated has made every effort to provide accurate information, but offering is subject to errors and omissions, as well as prior sale, change or withdrawal without notice and approval of purchaser by owner.

PREVIEWS LISTING NO. 50087

FARM BUILDINGS

Main Barn—42 steel stanchions, attached horse barn, hay storage for 120 tons, grain storage, two solid concrete silos.

Second Barn—17 steel stanchions, 9 steel box stalls, hay storage for 40 tons, grain room.

Dairy—Two large rooms equipped with two 10-40 qt. can coolers and new boiler for sterilizing and pasteurizing. (Suitable for retail business or the continued making of special Grade A milk.)

Implement Shed · Pump House · Work Shop

Manure Sink connected to barns by conveyor

Ice House · Hen House

Shed with space for four cars

Street for sale.

The Corner Store at the intersection of Bridge and Lamb Streets was typical of the many small neighborhood stores around town. Martin Dressel bought the land with a house in 1864 and the store was subsequently built. The family ran it for many years and then rented it to a number of people. In 1952 Myron W. Ryder Jr. bought the property and established the Ryder Funeral Home. The store was demolished.

Dietel's Drug Store on Main Street was an institution in South Hadley Falls for many years. Records show a pharmacy operating at that address since the 1820s and possibly the 1790s. It was operated by various owners over the years. It was called Dietel's after Charles Dietel took it over in 1923. Dietel retired in 1968, but subsequent owners retained the Dietel name. The last owner, Michael Cotter, closed the store on October 5, 1995. (Courtesy of Michael Cotter.)

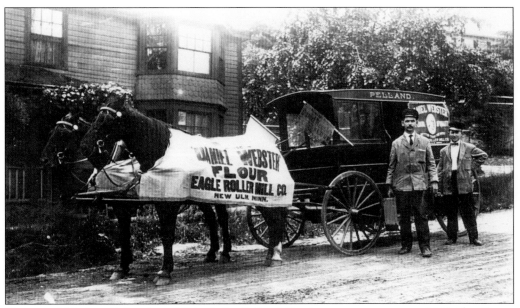

Oscar and Medore Pelland established the Pelland Brothers grocery store at 26 Bridge Street about the turn of the century. In 1909, it was moved to the Pelland Block at 30 Bridge Street, and operated there until the mid-1920s. Charles Pelland, another brother, joined the company, and Medore left to set up a grocery store at 104 Main Street. They advertised free home delivery which was made by horse and carriage.

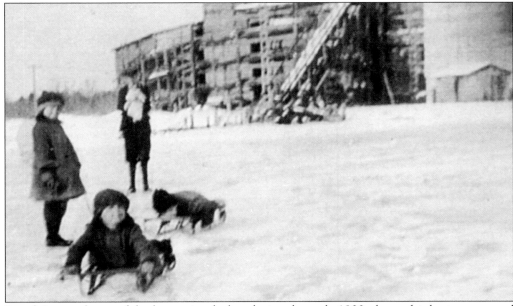

Joseph Legrand, one of the largest ice dealers during the early 1900s, began his business around 1910 on the Granby Road, cutting his ice from nearby ponds. His sons joined the company which became the longest lasting one in the area. With the development of electrical refrigeration, the company began to manufacture its ice about 1928. The company went out of existence about 1960.

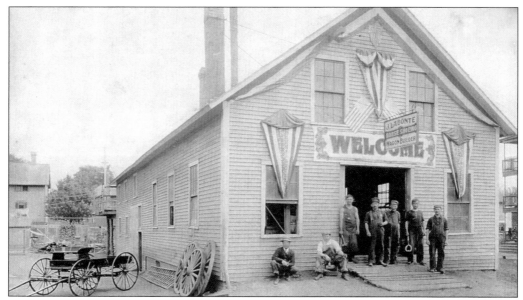

The Labonte blacksmith and wagon-building shop appears here decorated for the town sesquicentennial in 1903. Joseph Labonte operated his shop at 61 Bridge Street, about 150 feet below its intersection with Lamb Street, from 1903 until c. 1942. Frank Fernandes rented it and ran a blacksmith shop there from 1945 until 1950. After being vacant and then rented as a storage warehouse for a few years, the property was sold in 1959 and the building was razed.

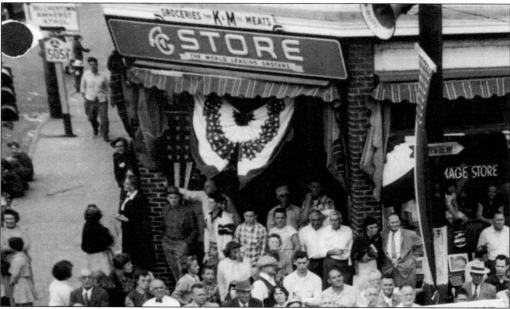

The K&M market was a fixture in South Hadley Falls for more than 37 years. It was first located on the southeast corner of Main and Bridge Streets and then moved to the northeast corner. William F. Keogh and Harold J. Moynahan opened the meat and grocery store about 1922 and operated it until December 1959 when they sold it. It was replaced by a package store and then a gas station.

Three

SCHOOLS

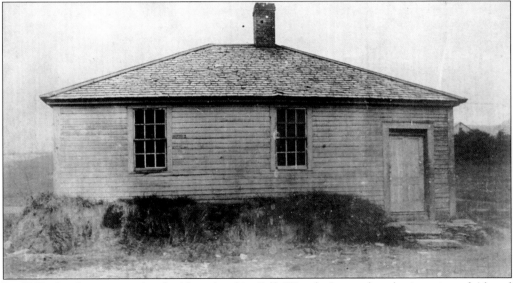

In 1769, the district voted to build a school in Falls Woods. It stood at the junction of Alvord and Lyman Streets. The building had two rooms that accommodated as many as 90 pupils at a time. It was superseded by a brick building at the corner of Alvord and Pine Streets.

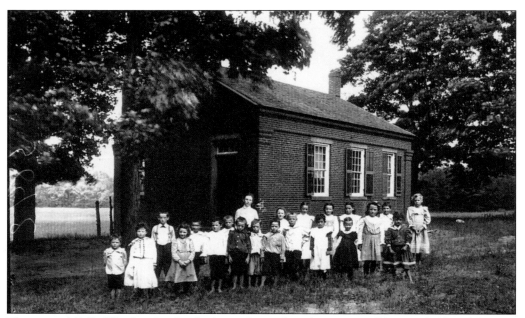

The second Falls Woods school, which was located at the corner of Pine and Alvord Streets, was built in 1848. The last class held there was in 1907.

This is, as far as is known, the first school building in Canal Village. It was built in 1794 about where Doctor Whitcomb's house stood at 31 Bardwell Street. It was moved in 1818 to the lot between the Methodist church and Mrs. Charles Bardwell's residence on Carew Street. It was moved in the 1830s to what is now Crescent Lane.

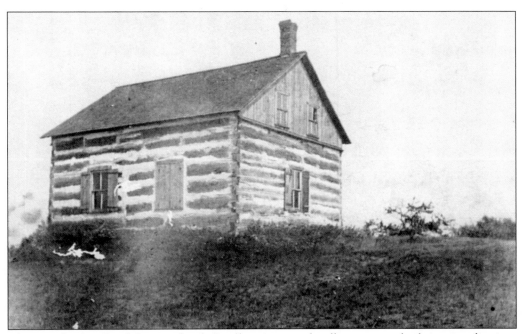

This was the first Pearl Street school. Small one-story schoolhouses were built in nine districts. The Pearl Street school was in district #4 and John K. Judd was the first teacher in this school.

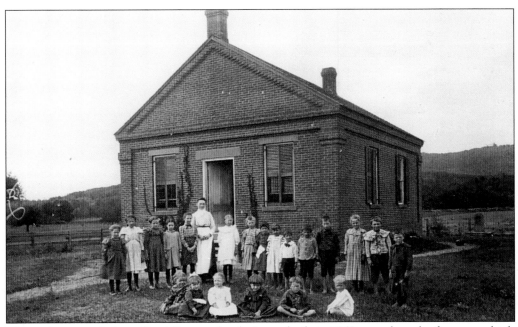

This is the second of two Pearl Street schools. It was built in 1869 to replace the first one which was built in 1829. It is located at the junction of Woodbridge and Pearl Streets and is now a residence. It has been renovated and a second story has been added.

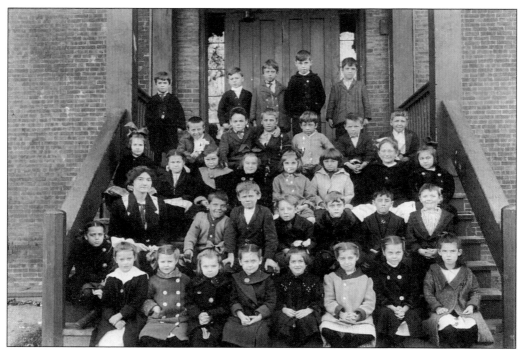

This third grade class picture was taken on the back steps of the School Street School on September 13, 1913.

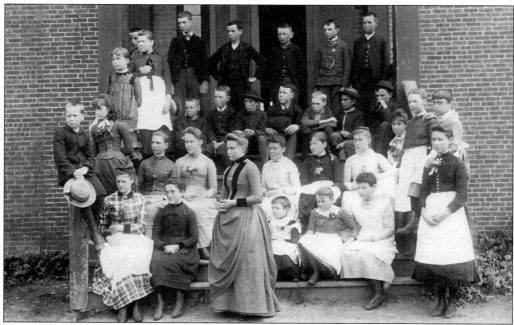

The School Street School pupils were photographed in June 1888 on the back steps. The teacher, Imogene Ford, later married Willis Wood, owner of Wood's Drugstore. Students Webster, Brainerd, Judd, O'Gara, Camp, and Smith later became well known in South Hadley.

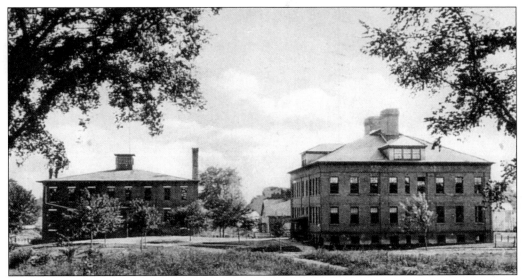

The building on the left is the School Street School, which opened as a grammar school in 1851. High school classes were added later. It closed in 1932. The building on the right is the old Carew Street School, which held the primary grades. This school was built in 1900 and served until the late 1950s.

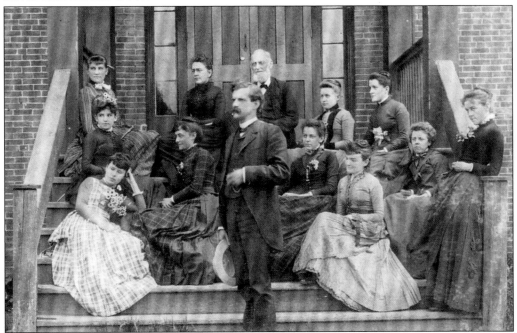

Pictured are the School Street School teachers and principal in June 1888. From left to right are: (front row) Gertrude Welcher (Mrs. R.O. Harper),Wilmot R. Jones (principal), Minnie Horton (standing), and Grace Skinner (Mrs. Derome, standing); (second row) Kate Moriarty (died 1891), Ida MacGowan (Mrs. Samuel Green), Myra L. Judd (later married Mr. Jones), and Sadie L. Stimson; (back row) Alice S. Makepeace, Sarah E. Burrall, William B. Wilder (janitor), Imogene Ford (Mrs. W.H. Wood), and Mary Barney (Mrs. Thayer).

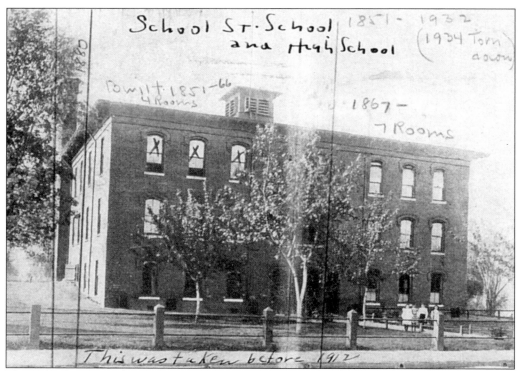

The School Street School, the first high school in South Hadley Falls, was opened in 1851. It served at first as a grammar school serving grades one through nine. Later, high school classes were added. It was enlarged from 1867 to 1868 and from 1879 to 1880. The first high school class was graduated in 1870. The School Street School closed in 1932 and was demolished in 1934 with Works Progress Administration funds. The Center School high school was combined with the School Street School on April 5, 1897. Small outlying district schools were closed and the high school moved to town hall in 1914.

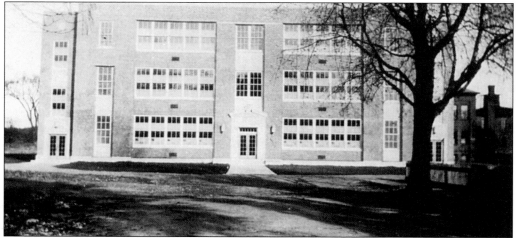

As the need for more space grew, the New Carew Street School was built in 1932 at a cost of $135,000. It housed grades four through eight, two rooms each, and contained the superintendent's office, the health clinic, and an auditorium.

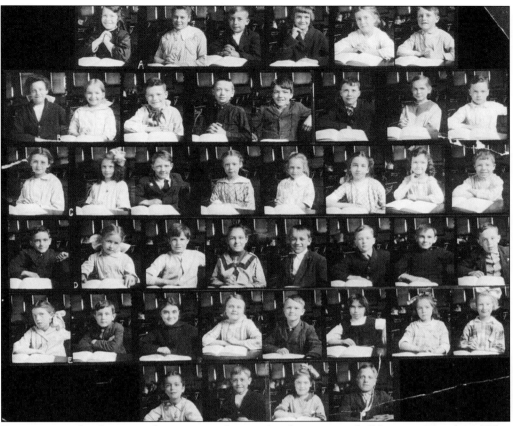

Do you remember having a class picture taken in the classroom and all being on one sheet? This is the class of 1915–1916 from the School Street School.

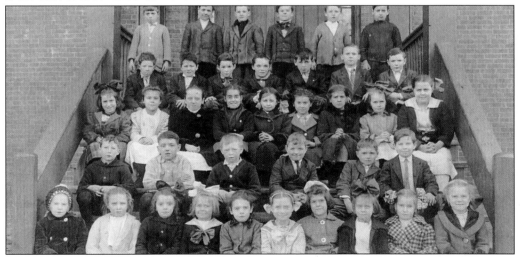

This picture of the first grade at the School Street School in 1911 shows Esther Scott, the founder and past president of the South Hadley Historical Society and who later married George Moos, in the first row first on the left.

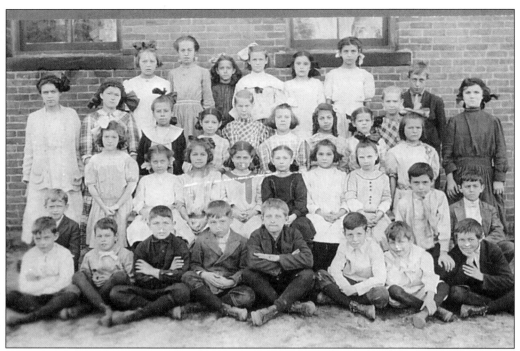

In this picture of the Center School about 1908, the teacher, Bertha Brainard, is in the third row at the far left.

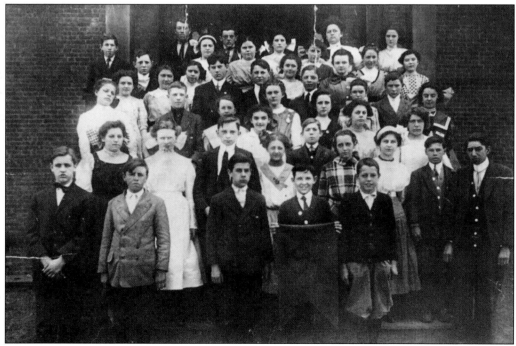

The 1911 ninth grade graduation exercises were held at the firehouse on North Main Street. The teacher, Bessie Skinner, is in the top row, second from the right.

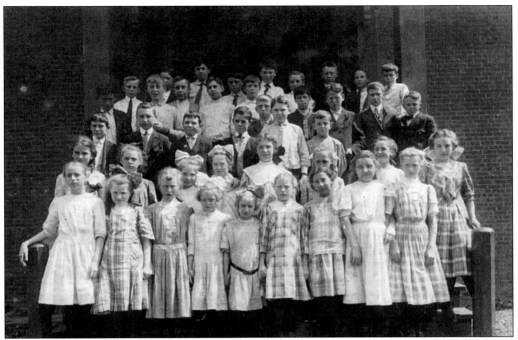

The last ninth grade graduation in the South Hadley school system was in 1914. It was held in the basement of the School Street School.

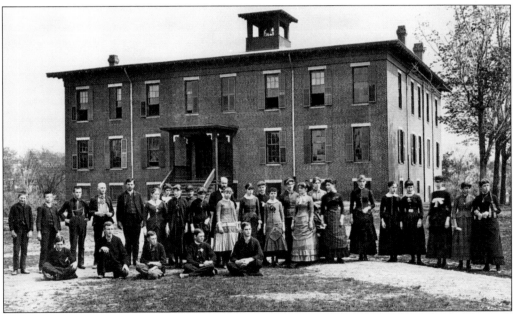

A picture of the high school class at the School Street School about 1900 was taken at the back of the building. Note the bell on the roof that was rung to signal ends of periods, recess, and other occasions.

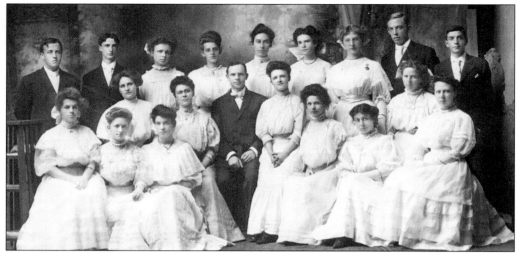

This is the South Hadley High School graduating Class of 1907. The graduates, from left to right are: (front row) Bessie Young, Wilma Schmidt, Margaret Sullivan, Florence Fricker, Alice Lyman, and Helen Lyman; (middle row) Maude Carey, unidentified, Mr. Cook, Miss McDonald, and Delia Quirk; (back row) Chester Strong, Raymond Cunningham, Mabel Cordes, Marian Tiffany, Mary Harris, Grace O'Keefe, Eva Miller, Everett Miller, and Tom Downs.

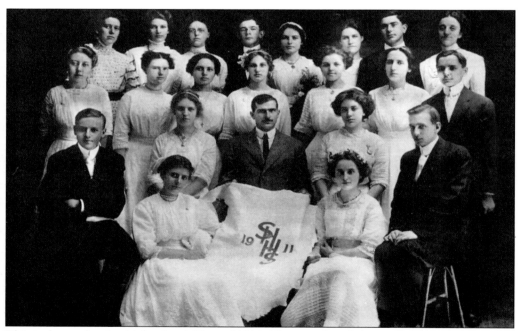

This is the graduating high school Class of 1911. They are from left to right: (front row) Helen Wood and Bessie Stafford; (second row) Charles Hofmann, Ruth Fricker, George Turner (principal), Bessie Cooke, and Frank Judge; (third row) Ruth Lyman, Eleanor Strong, Leocadia Rabinski, Daisy Ford, Rhea Fillion, Helena Quirk, and William Boerner; (fourth row) Frances Dodge (teacher), Clessie Putnam (teacher), Edith Perkins (teacher), Francis Fitzgerald, Anna Sheehan, Elgina Mortensen (teacher), James J. Shea, and Blanche Samuels (music teacher).

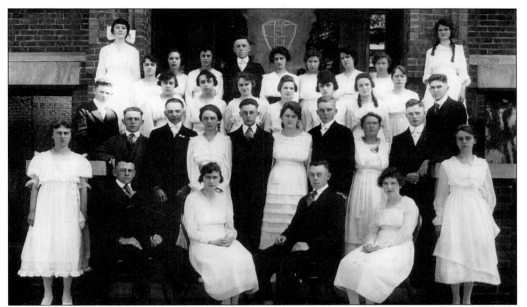

The graduation of the South Hadley High School Class of 1918 was held on June 26, 1918 in the town hall auditorium. A few of the graduates were: Hazel L'Esperance, Florence Frey, Carl Boerner, Vernon Bagg, Francis L'Esperance, Esther Jackson, John Long, and Marian Britton. Nellie Cross, the teacher, is under the sign in the back row.

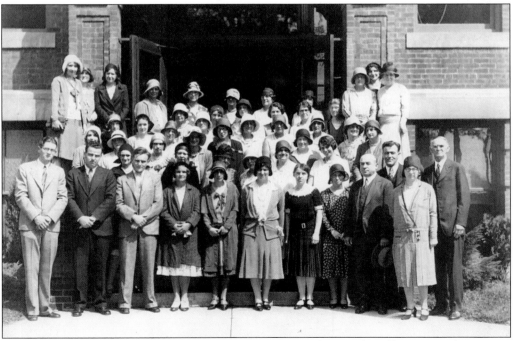

In this 1930 photograph of the School Department teachers and staff in 1930, there are a number of familiar faces and notable names. Among these are Jeremiah Foley, Komah Atwater, Hilda Fleming, Helen O'Gara, Bessie Skinner, Eleanor Garrity, Anne Driscoll, Nellie Cross, and Thomas Auld.

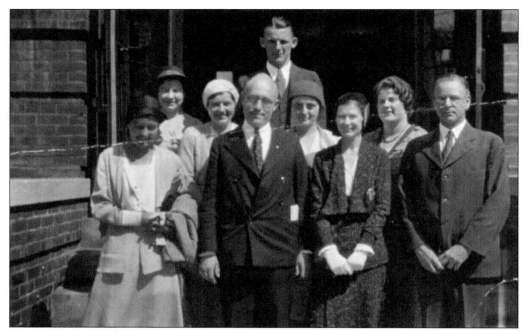

This photograph of the South Hadley High School staff about 1930 includes the principal, Donald B. Stevens, Dan Connor, Maybelle Pratt, Marguerite Pearce, Eleanor Garrity, and Ruth MacDonald.

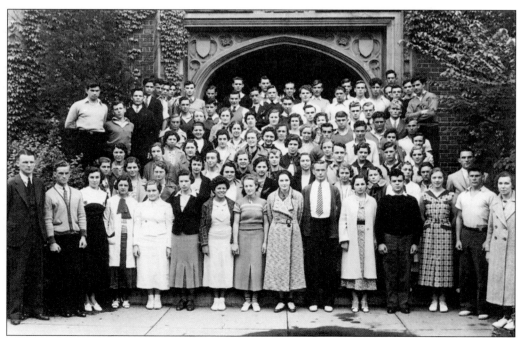

This picture of the South Hadley High School Class of 1935 was taken in front of the Student Alumnae Hall at Mount Holyoke College on June 20, 1905. Daniel Connor, the class faculty advisor, is in the first row at the left.

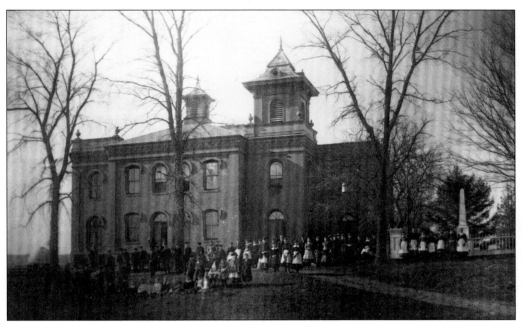

The Center School stood opposite the Field Memorial Gate and Mary Lyon Hall on College Street. It was built in 1879 and served as a grammar school and then a combined grammar and high school. It became overcrowded, and on April 5, 1897 the high school was combined with the high school in the School Street School.

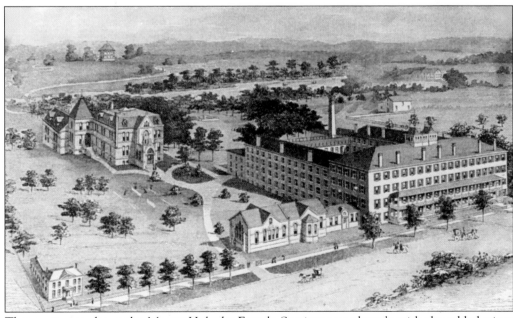

This engraving shows the Mount Holyoke Female Seminary quadrangle with the added wings and other buildings before the 1896 fire. (Courtesy of Mount Holyoke College Archives and Special Collections, Masseng Company.)

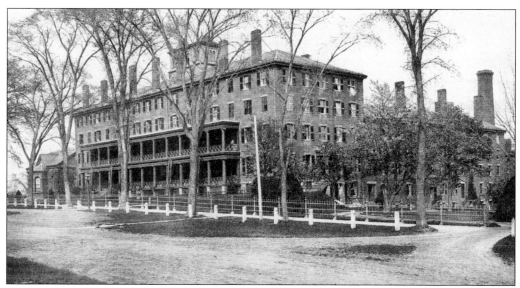

When Mount Holyoke Female Seminary, now Mount Holyoke College, was founded in 1837, the classrooms, chapel, dormitory rooms, kitchens, dining rooms, and laundry were located in one building. A south wing was added in 1840 and in 1853, a north wing. In 1865, the two wings were connected by a building containing the gym, laundry, and machine rooms, creating a quadrangle. The complex was destroyed by fire in 1896. (Courtesy of Mount Holyoke College Archives and Special Collections.)

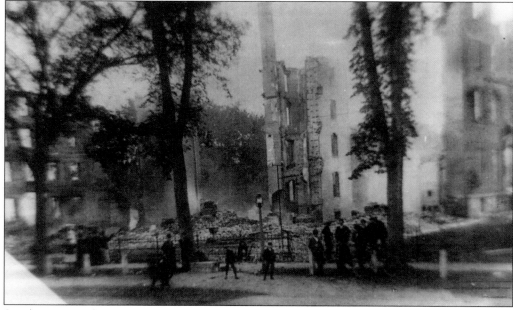

Sunday, September 27, 1896, the Mount Holyoke Seminary building was destroyed by a fire which was believed to have started either in the laundry room or machine room. The library was saved when the corridor connecting it with the seminary building was torn down. There was an outstanding display of town-gown cooperation as town residents rushed to help rescue property and later housed many of the students in their homes.

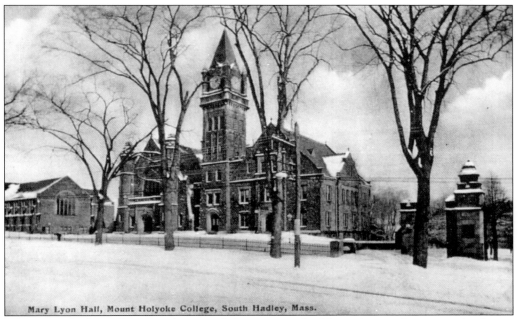

Mary Lyon Hall, Mount Holyoke College, South Hadley, Mass.

Mary Lyon Hall was built on the site of the seminary building after its destruction by fire in 1896 and is now used to house administrative offices and a chapel.

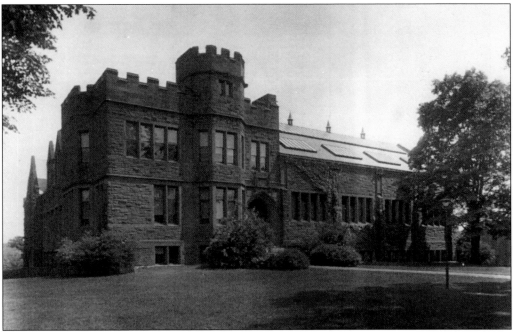

Dwight Hall, which is on the site of the Dwight homestead, is now used for offices by Mount Holyoke College. John Dwight, Elihu Dwight's son, became wealthy after establishing a company producing baking soda. In 1900, he donated $60,000 for the building of the Dwight Memorial Art Building in memory of his wives and family. It served as the art building until 1971. The homestead was moved to the rear and became the infirmary.

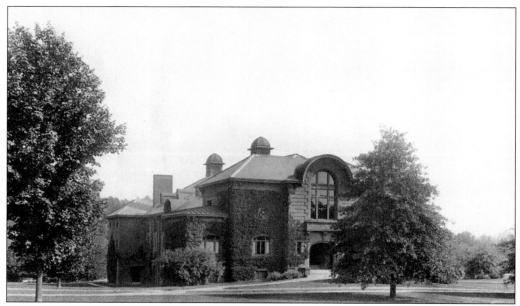

Blanchard Hall was built in 1899 and named for Elizabeth Blanchard, principal and president from1883 to 1889. It served as the gymnasium until 1950 when it was converted into offices and the college post office. It was renovated in 1988 as a student center.

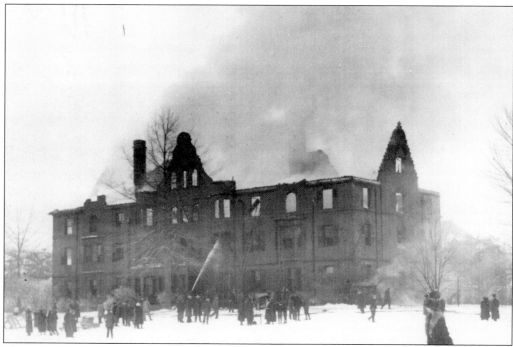

The college dormitory, Rockefeller Hall, was named for John D. Rockefeller Sr., a benefactor of the college. It burned in December 1922 just before the start of Christmas vacation. A year later a larger two-unit building was erected with generous aid from John D. Rockefeller Jr. and bearing the family name.

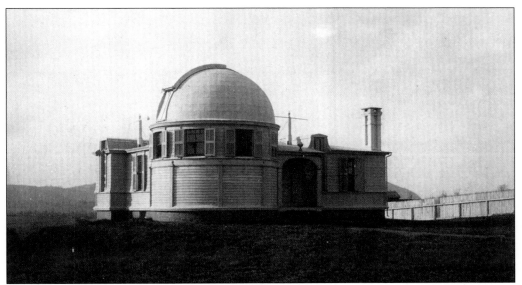

John Payson Williston Observatory was built in 1881 and given in memory of the Williston's eldest son. It was built to be ready for the rare transit of Venus in 1882. It is the oldest academic building on campus.(Courtesy of Mount Holyoke College Archives and Special Collections.)

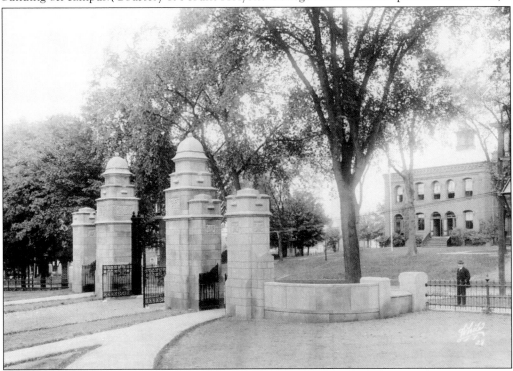

The Field Memorial Gateway was formally opened in 1912 during the 75th Anniversary Celebration of Mount Holyoke College. It was given in memory of Fidelia Nash Field, the daughter of a generous donor to the Seminary, by her children. (Courtesy of Mount Holyoke College Archives and Special Collections.)

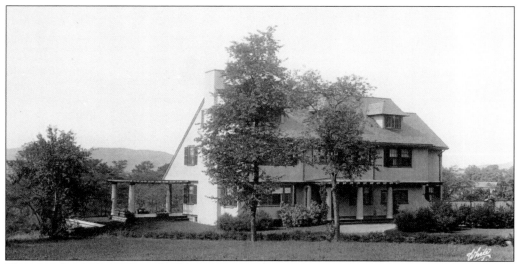

The president's house was built in 1908 as the result of a proposal by the Northwestern Alumnae Association which urged a separate household adapted to the president's needs and the entertainment of distinguished guests of the college. It is located to the rear of Pearsons Hall and the Gaylord Memorial Library. (Courtesy of Mount Holyoke College Archives and Special Collections and John B. Sutcliffe.)

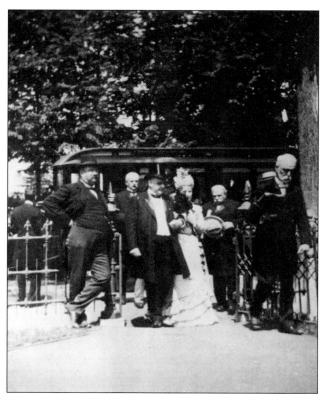

The only United States President to visit South Hadley during his term of office was William McKinley, who came in 1899 with his wife to attend the graduation of his niece, Grace Howe McKinley, at Mount Holyoke College. He gave a brief speech and presented the diplomas to the graduates. He received honorary degrees from Smith College and Mount Holyoke College, making him the first president to accept a degree from a women's college. (Courtesy of Mount Holyoke College Archives and Special Collections.)

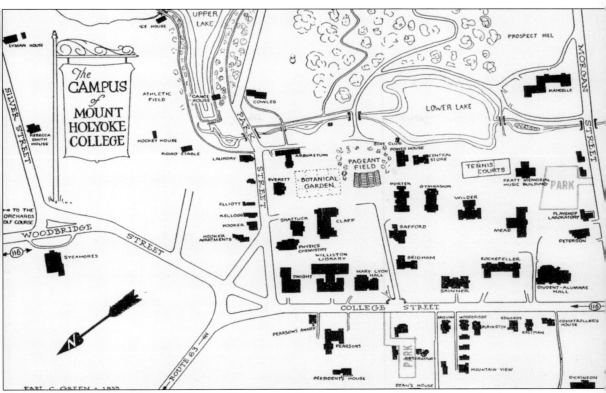

This is a map of the Mount Holyoke College campus in 1935 showing the locations of the buildings.

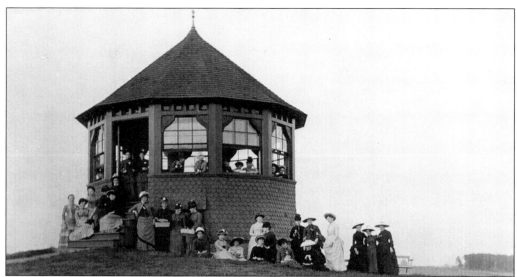

The Pepper Box was a 12-sided pavilion painted dark red on the summit of Prospect Hill on the Mount Holyoke College campus. It was built in 1884 and acquired its name from its shape, which resembled that of the box of a popular brand of pepper. It was a favorite spot for the students to visit and hold picnics. It became a target of vandalism and was taken down. (Courtesy of Mount Holyoke College Archives and Special Collections.)

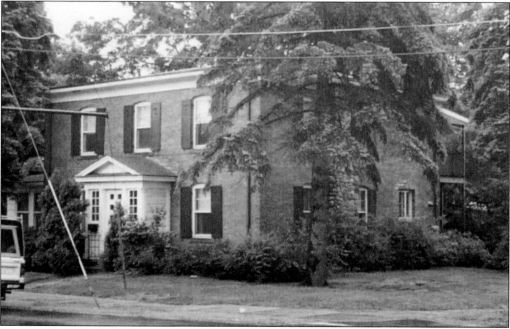

The South Hadley Academy Association, formed by 19 members of the First Congregational Parish, established the Mount Tom Academy in the brick building at the corner of Park and Woodbridge Streets in the late 1840s. It provided a basic college preparatory education. Unfortunately it went out of existence by 1857, when the building was used for the town's first high school in the Center.

Four

PEOPLE, HOMES, FARMS

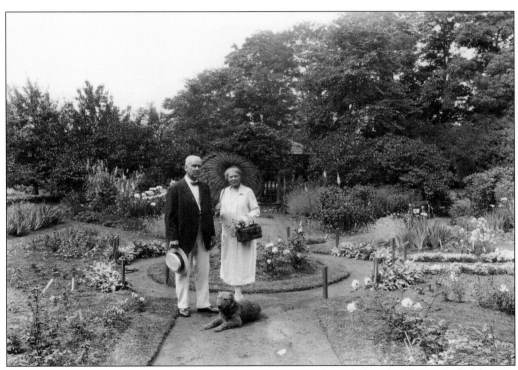

Fred M. Smith (1862–1928) was prominent in civic, social, and church affairs. He held many town positions and served as a representative to the state legislature. The park at the corner of Main and North Main Streets was named in honor of his many contributions. His wife, Evelyn, was active in community and church affairs, and was noted for her garden. She died in 1969 at the age of 107.

Fifty-six members of the Lamb, Judd, Strong, and Searle families attended a 1906 gathering. Among them were Louis Lamb, Mrs. Lily Lamb (holding Elizabeth Lamb Small next to column), Hazel and Millie Judd (left of left column).

Mr. and Mrs. Harry Bates were honored on their 40th wedding anniversary in 1940 at a party attended by members of the Bates, Burnett, and Selkirk families.

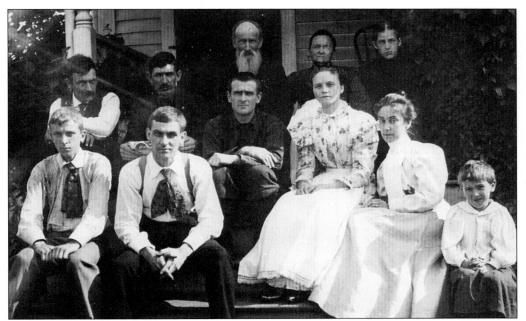

In this gathering of the Scott family in the late 1800s, Wilfrid Scott (first head of the South Hadley Electric Department) and Ray are seated at the front. In the second row are Charles, Earl, Arthur, Angelina, Elizabeth, and Beulah. In the last row are Hugh, Achsah, and Emma. (Courtesy of Phyllis Bannerman.)

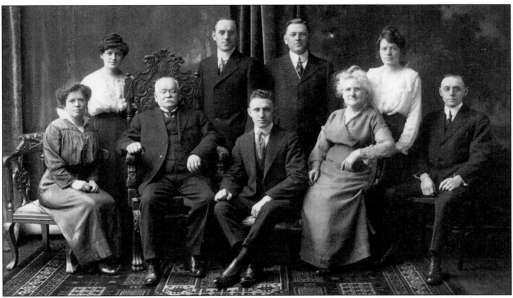

The Websters were a prominent family in South Hadley during the early decades of the 20th century. Seated are Clara, Benjamin, Clark, Elizabeth Parfitt, and George Webster. Standing are Ethel Webster Stevens, Arthur Webster, F. Herbert Webster, and Ruth Webster Winslow. F. Herbert Webster was office manager at the Carew Manufacturing Company and served as a selectman and also as a member of the school board. (Courtesy of Marion Lippman.)

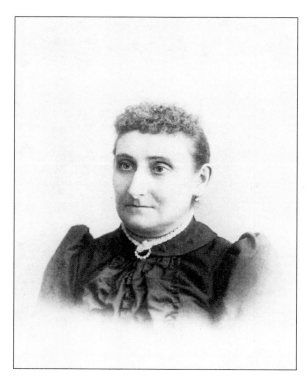

Sophie Eastman was the author of *In Old South Hadley*, the only complete volume devoted to South Hadley history. Her father, Charles Eastman, was a prominent merchant. She graduated from Wheaton Seminary, now Wheaton College, and taught for several years. She was active in community and social affairs, and attempted to start a town library.

Joseph Carew (1807–1881), major owner of the Carew Manufacturing Company and prominent citizen, was also active in other business enterprises as well as civic and church affairs. He served as selectman and representative to the Massachusetts legislature. He and his wife built the Congregational Church of South Hadley Falls and deeded it to the trustees. He built his handsome combination Greek Revival- and Italianate-style house at 55 North Main Street. (Courtesy of the Congregational Church of South Hadley Falls.)

William H. Gaylord (1821–1904) was a prominent businessman who owned an interest in Howard, Gaylord and Company and other businesses. He and his wife, Betsey, were civic-minded and were active in town and church affairs. They donated an organ to the First Congregational Church and the monument on the town common. They donated the money to build and endow the Gaylord Memorial Library as well. Both died on December 22, 1904.

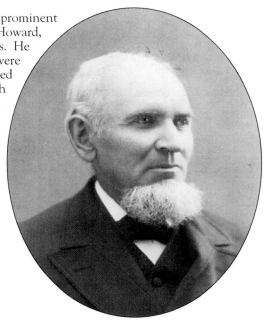

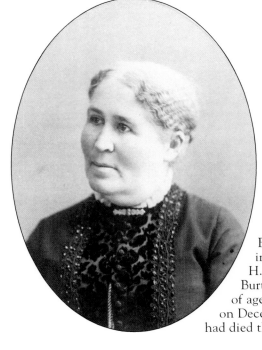

Betsey Stone Gaylord (1830–1904) was born in Madison, New York. She married William H. Gaylord on September 8, 1858. Their son Burton, a promising young man almost 20 years of age, died on March 20, 1880. Mrs. Gaylord died on December 22, 1904 in the afternoon. Her husband had died that morning.

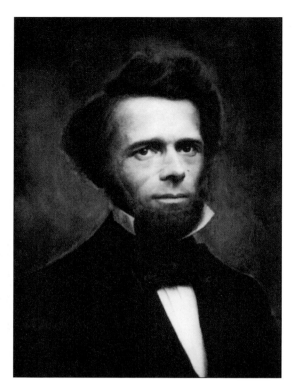

Joseph Goodhue Chandler (1813–1894), a native son, was a well-known figure in 19th-century American folk art. He spent a decade as an itinerant painter and maintained a studio in Boston for eight years. He painted several hundred portraits, some of which are in important museums such as the National Gallery of Art in Washington and the Boston Museum of Fine Arts. He married Lucretia Ann Waite, also an established painter. (Courtesy of Mount Holyoke College Archives and Special Collections.)

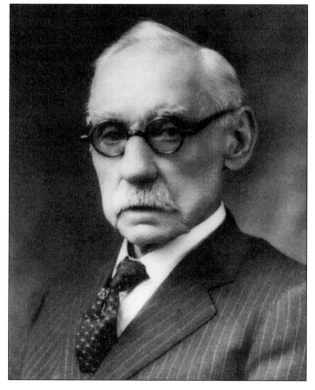

Henry E. Gaylord (1846–1927) was public spirited and contributed much to his community. He held many town and state offices including selectman, assessor, water commissioner, volunteer firefighter, state representative, and later senator. He served for years as president of the Gaylord Memorial Library Association and was active in other organizations. He started a coal and wood business that became one of the largest in Holyoke and was active in other businesses.

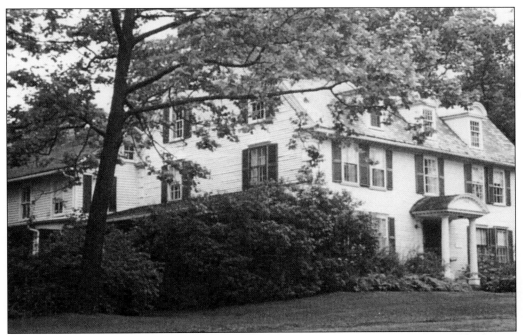

The Sycamores, one of the oldest houses in South Hadley, is part of the Woodbridge Street Historic District listed in the National Register of Historic Places. It was built in 1788 by Ruggles Woodbridge, the town's wealthiest citizen. After his death, it had several different owners. In 1915, Joseph Skinner bought the property and let it be used as a residence by Mount Holyoke College students. The college bought it in 1937.

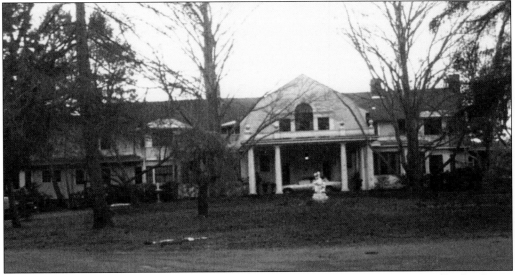

Joseph Skinner, prominent Holyoke industrialist, bought the property at 48 Woodbridge Street in 1906 as a summer place. The original small house was enlarged and by 1915 had about 20 rooms. He made many contributions to the community and Mount Holyoke College of which he was a trustee between 1905 and 1931. Among these were the Skinner Museum, the Orchards Golf Course, and Skinner State Park.

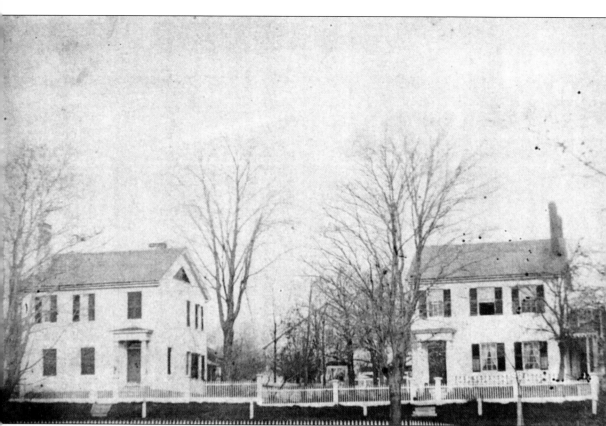

The two stately Bardwell houses once stood to the right of the Methodist Church on Carew Street. Alonzo Bardwell built the two houses in 1819 for himself and his son, Charles A. Bardwell. The Bardwells were prominent businessmen in the Falls. The two houses were identical, but one was the reverse of the other, so the side porches faced each other. Bardwell Street was then called Market Street and extended only as far as Carew Street. In 1873, the house belonging to Charles was razed so that the street, whose name was changed to Bardwell, could be extended to its present length. Alonzo Bardwell died in 1868 and his son took over his house. The house remained in the family until 1955 when it was sold to the Methodist church. It was later demolished and a new church wing was built.

By tradition, 89 Woodbridge Street was the Chileab Smith house for whom Chileab's Hill was named. Deacon Ebenezer Moody gave the land in the area to his daughter Sarah, when she married Chileab Smith in 1732. A small house was built which today forms the ell of this house. Changes were made by later owners. Pictured from left to right are: Janette Clapp, Potwine Burnett, John Leonard Burnett, Vera Iona Burnett, Erry Marshall Burnett, and one unknown.

The Mosier Elementary School and Middle School North are located on what was formerly Ashley Mosier's farm. He bought what had been Jotham Graves's farm in 1872. After Mosier's death the property remained in the family until taken by the town through eminent domain in 1959. In this photograph, Mrs. Mosier is standing inside the fence. Outside the fence are Marion Spafford, Mrs. Spafford (holding Ruth), and William, Arthur, and Walter Spafford.

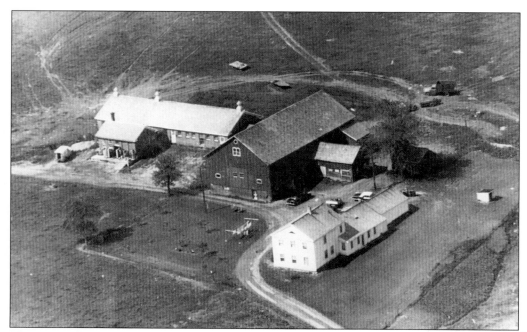

The Howes farm was once located on Alvord Street where the Rexam Research Center is now. Frederick and Newton Howes bought it from Samuel Whiting Jr. in 1943. Frank Jesionowski and his son bought 29 acres of the farm in 1958, rented the rest, and continued to run the dairy business. In 1965 the entire farm was sold to Plastic Coating Corporation, and then went through several other owners. (Courtesy of Frank Jesionowski.)

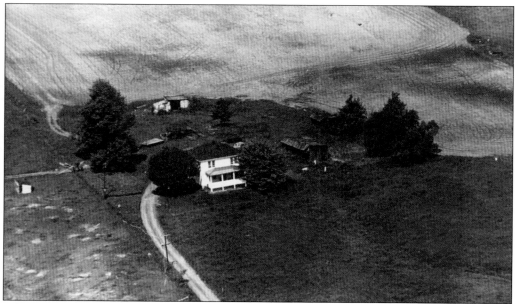

After the Howes farm was sold, the old farmhouse was demolished. The smaller house, which had been renovated, was moved to McCray's farm farther north up Alvord Street. (Courtesy of Frank Jesionowski.)

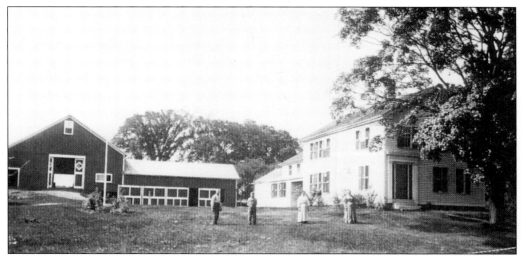

This photograph shows the Charles Judd farm in the 1890s and early 1900s. Anthony Ciolek bought Judd's 70-acre farm in 1919 and enlarged it. He raised cattle, hay, and vegetables and produced milk. Ciolek died in 1942. His wife continued to live in the house until 1960 but began to sell some of the land for homes. After her death in 1961 the farm was broken up for residential development.

The Lauzier house has been renumbered and is now 73 Alvord not 17. It was built in the early 1800s probably by Josiah Gaylord. It remained in the Gaylord family until 1904 when it was sold to Adelard Paul. It passed through several owners. The last two operated a dairy business. During the early 19th century it served as an inn. The house has gone through a number of changes over the years.

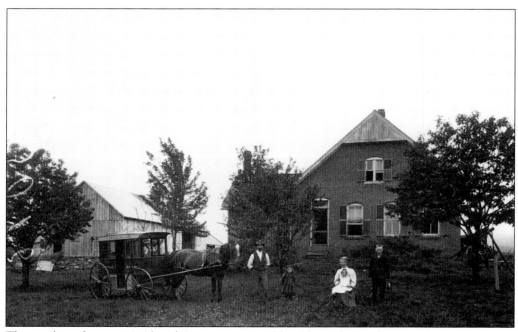

This working farm at 12 Alvord Street was owned by Alexander J. Thompson during the early 1900s. The brick building was later painted white. Note the horse-drawn mail cart on the lawn.

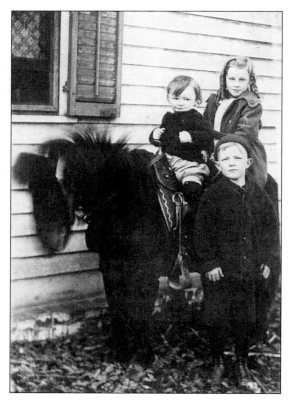

Every year some photographer would come with a pony and take photos of the children. Seated on the pony are Donald and Margaret Bain, and standing is Alexander Bain, all children of James and Margaret Bain. (Courtesy of Margaret Bain McDonnell.)

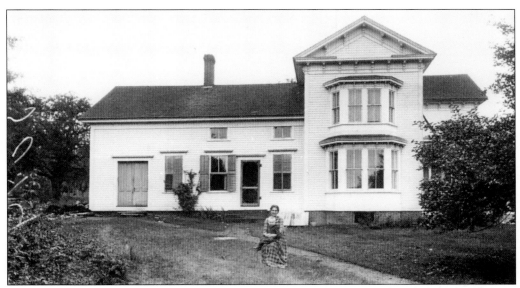

The Bagg farm, one of the farms once active on Alvord Street, is reduced in size and serves residential purposes only. Hiram Abiff Bagg bought what was called the Eaton Farm in 1852 and 1853, and later bought additional land. The farm was pretty self-sufficient. After Hiram died in 1879, the family continued to operate the farm. In the1930s, Millard began driving a school bus for the town. In 1954, he and his brother Malcolm organized the Bagg Brothers to carry on school busing for the town. They discontinued farming.

Hazel Bagg, Hiram's granddaughter, used to ride the all-duty horse, Jess, to South Hadley Center to get the mail. Also along for the ride is grandson Mackie. (Courtesy of Eunice Watts.)

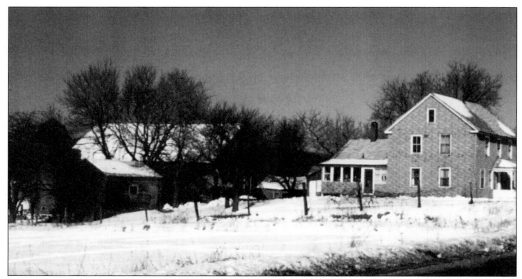

The Klepacki farm was one of the old farms located on Alvord Street. It can be traced back to 1800 when Ruggles Woodbridge sold 170 acres with buildings to Jesse Brewster. The farm was owned and run by a number of owners until November 4, 1920, when Walter Klepacki bought it. He ran a milk business and did some truck farming until his death in 1958. The farm was later sold to developers.(Courtesy of Eleanor Klepacki.)

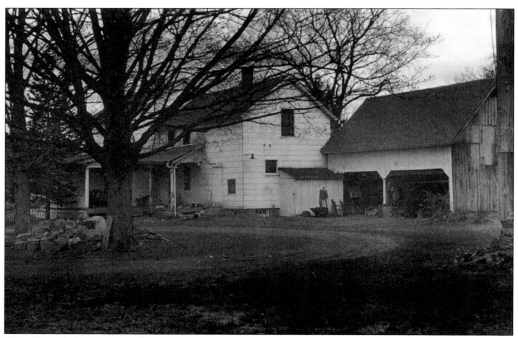

The Oertel farm on Willimansett Street is now the site of the South Hadley Square retail center. The farmhouse was moved to Old Lyman Road and refurbished. Leonard Oertel bought the farm in 1888 and operated it until his death in 1946. His son August continued to run it until his death in 1993. (Courtesy of Mark Mueller.)

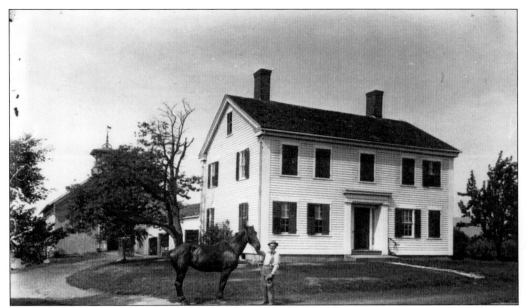

This old farmhouse at 246 North Main Street is believed to have been built in the 1780s. It was owned for most of the 19th century by Willard Judd, and a large barn was connected to the house. The barn was cut down to a more manageable barn. It was owned by Leodore Pin, who ran a tree farm and sold the property to Loomis Village.

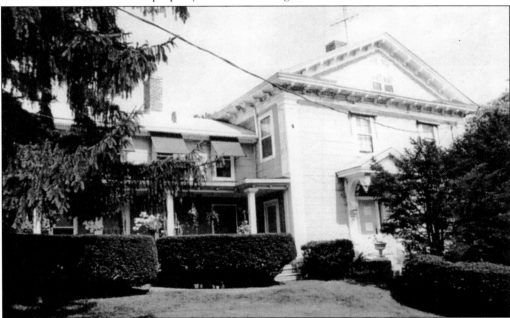

One of South Hadley's historic houses is the house built in 1839 by Joseph Carew at 55 North Main Street. The property originally included more land, a barn, and a carriage house. The house is an eclectic combination of Greek Revival and Italianate styles with marble fireplaces in each room. Much of the original ornamentation, cupola, and balconies are gone, but the house still presents a handsome appearance.

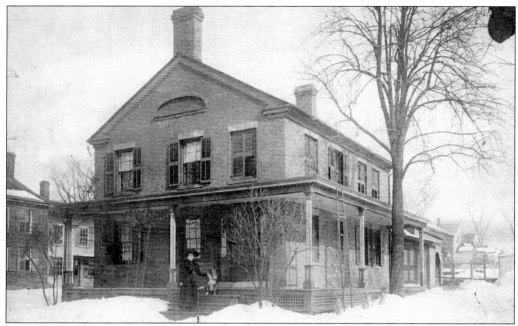

This is one of South Hadley's old homes. It was built about 1855 in the Greek Revival vernacular style. It went through various owners. The Carew Manufacturing Company bought it in 1868 for $2,800 and sold it in 1886. During the period of Carew ownership, Asa B. Gaylord lived in the house, and he owned a similar house next door at 138 Main Street.

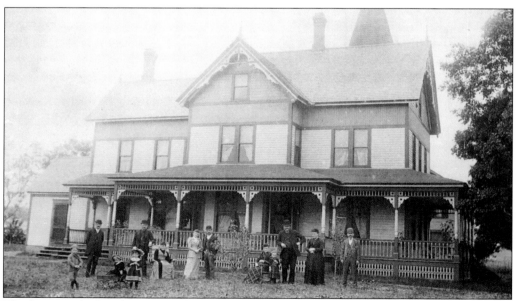

This house at 52 Canal Street was built for Sanford Thayer, owner of Holyoke and South Hadley Falls Ice Company. It was acquired by George Everson. Among the people in this photograph are: George Everson, Emma Thayer Everson, Sanford Thayer, Howard Everson, Emily Avery Thayer, Herbert Thayer, and Eva Everson Thayer. (Courtesy of Agnes Everson.)

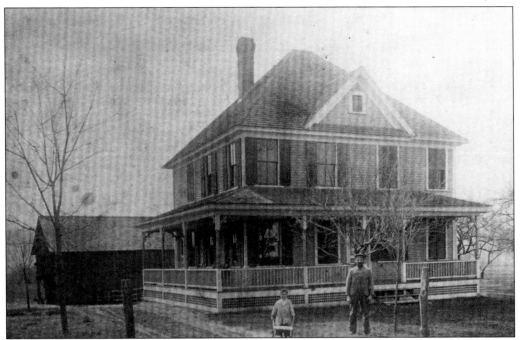

The house at 78 Hadley Street was once part of the Samuel W. Young farm of 57 acres and a wooded lot. Samuel Young is standing in front of the house with his son, Freeman Young, holding the wheelbarrow. After Samuel Young's death in 1939, everything was to be divided equally among his five children. Later, the property was sold to a developer. (Courtesy of Janet Smith.)

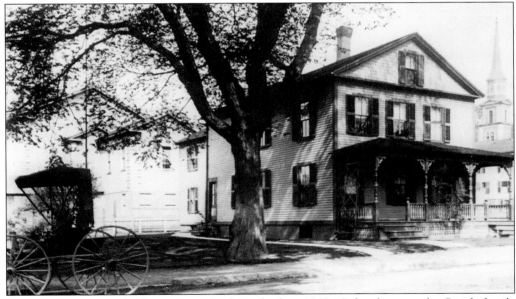

The house at 10 Bardwell Street was built in the late 1800s. It has been in the Smith family since 1898, when George I. Smith acquired it. The present owner, Henry Smith, reports that the beams in the attic are fastened with wooden pegs.

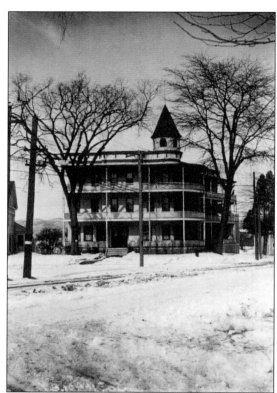

The former Woodbridge Hotel stood on the site of the present South Hadley post office. In 1882, Joseph S. Preston Jr. bought the land and built the hotel. It became a popular gathering place. Mount Holyoke College bought the property in 1908 and used it as a residence hall until 1932, renaming it Judson Smith Hall. It was taken down in 1934 and the lot was sold to the U.S. government.

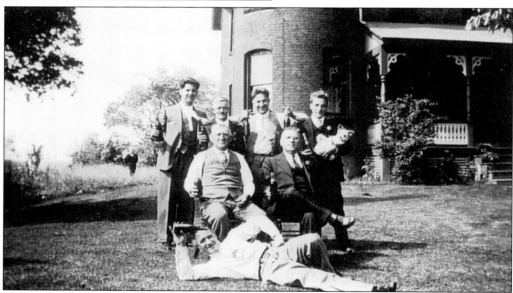

Kilkelly Castle, located part way up the hill on Granby Road, was a landmark. A three-story, ten-room house, it had what looked like a castle tower on the front. The house was built between 1892 and 1896 by Patrick Kilkelly and his sons, who were all bricklayers. The state took the property by eminent domain in 1958 and the house was razed to make room for the approaches to the Mueller Bridge.

The house at 315 River Road, one of the oldest houses in South Hadley, played a role in the history of the first commercial navigable canal in the United States. Built about 1820, it was located near the upper part of the canal. It was occupied by the person who tended the canal locks, and was called the Lock Tender's house.

The house at 88 Alvord Street which was once owned by the Judd family is said to have harbored slaves escaping to Canada through the Underground Railroad. The house was built by Zebina Judd about 1823 and was known as the Tri-Oaks Inn during the Civil War period because of three oaks at the side of the house. It was restored after surviving a bad fire in the 1960s.

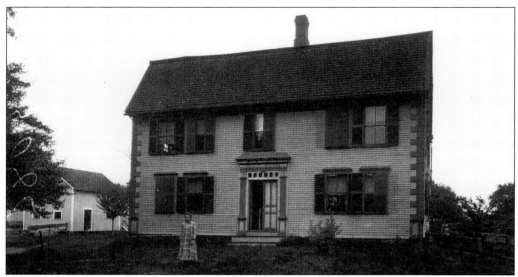

This house at 13 Alvord Street was built about 1746 and was owned by the Alvords until Asenath Alvord sold it in 1892 to George and Lucy Smith. Later, Frank Metcalf, a Holyoke industrialist, used it as his summer home in the 1930s.

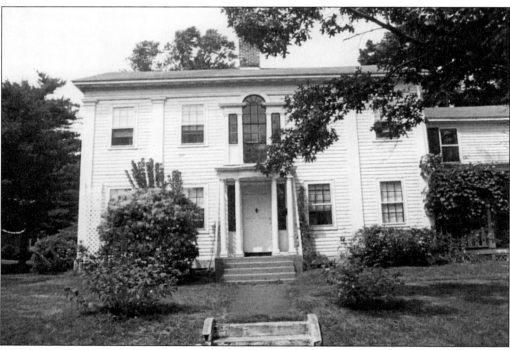

The Squire Bowdoin house was built by William Bowdoin (1813–20). It is an outstanding example of the Greek Revival style and its designs are similar to those of Asher Benjamin. Bowdoin was a prominent lawyer and civic-minded citizen. He held a number of important public offices and was one of the five men who drafted the charter petition for Mount Holyoke Seminary, now Mount Holyoke College.

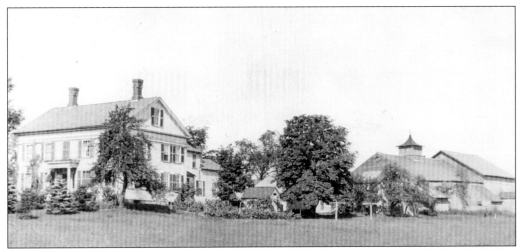

The handsome Lamb house and farm at 85 North Main Street was once a South Hadley landmark. It was built by Alonzo Lamb, a successful farmer and businessman. After his death on June 29, 1853, the property remained in the family until taken by eminent domain by the state in 1958 for relocation of Route 202, during construction of the Mueller Bridge. The house was scheduled to be razed but was previously virtually destroyed by fire.

The picturesque Victorian house at 108 College Street has had a colorful history. In 1924, fugitive felons Gerald Chapman and Dutch Anderson bought the house supposedly because Chapman's niece was going to attend Mount Holyoke College, and he wanted to be near her. Actually they planned to use it for counterfeiting, but Chapman killed a policeman during a robbery and was hung. The house is being restored by its present owners.

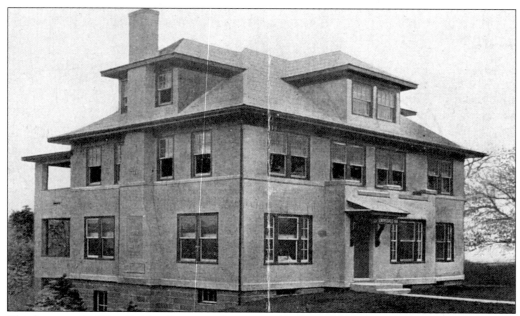

This house at 21 Woodbridge Street was known as the Croysdale Inn run by Frances and Isabella Parfitt from 1911 to 1930. It was also called, the House that Jack Built, because "This is the House that Jack Built" is cut into the outside of the north chimney. After having several owners, the building was acquired by Mount Holyoke College and is now used for faculty housing.

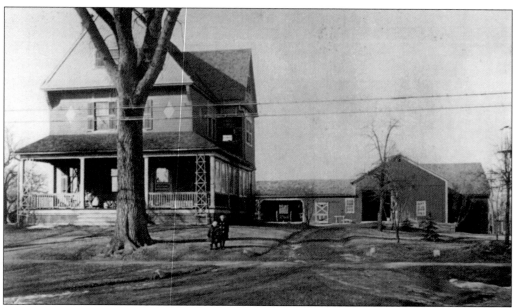

The Brockway farm of the early 1900s was located at 97 College Street. Beside the farmhouse were a carriage barn, storage barn, and hey barn. Behind the house was a cow barn with an adjacent horse barn. Standing in front of the house are Horace T. Brockway Jr. and his sister Kathleen. (Courtesy of Geri Brockway.)

Five

MILITARY, PUBLIC PLACES, EVENTS

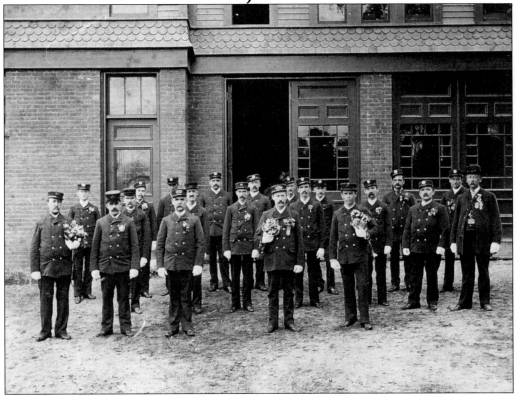

The members of the Pioneer Hose Company #1 stand before the Engine House (the present site of the Old Firehouse Museum) on Decoration Day (now Memorial Day) on May 30, 1889.

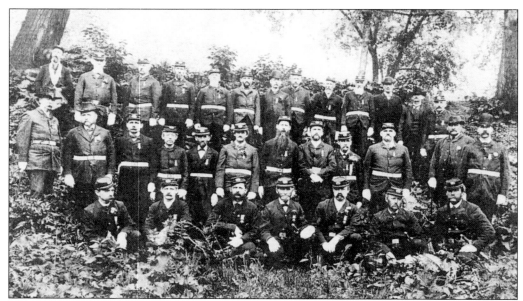

This photograph of the C.C. Smith Post No. 188 of the Grand Army of the Republic (commonly called G.A.R.) gathered on Memorial Day 1887.

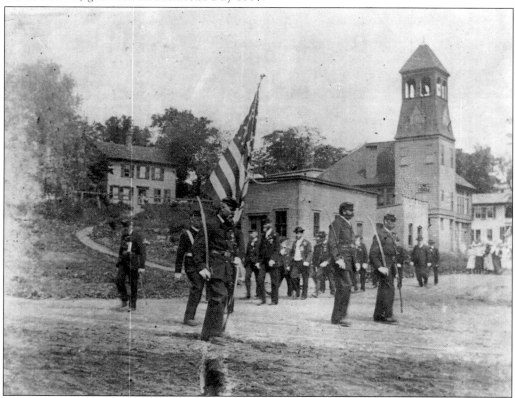

Civil War veterans march down North Main Street on their way to the Village Cemetery on Memorial Day about 1900.

Order of Induction into Military Service of the United States.

THE PRESIDENT OF THE UNITED STATES,

To_____

(Christian name.) (Surname.)

Order Number_____ Serial Number_____

Greeting: *Having submitted yourself to a local board composed of your neighbors for the purpose of determining the place and time in which you can best serve the United States in the present emergency, you are hereby notified that you have now been selected for immediate military service.*

You will, therefore, report to the local board named below

at_____, at_____ m.,

(Place of reporting.) (Hour of reporting.)

on the_____ day of_____, 19____,

for military duty.

From and after the day and hour just named you will be a soldier in the military service of the United States.

Member of Local Board for_____

Report to Local Board for_____

Date_____

(The term "military service" shall be held to include naval service, including service in the Marine Corps, except where such construction would be unreasonable.—Sec. 1, S. S. R.)

P. M. G. O. FORM 1028. (See Sec. 157, S. S. R.)

This is a copy of the induction order received by the many who were drafted into military service during the "Great War" from 1917 to 1919. Approximately 300 men from South Hadley served in the armed forces; six joined the British and Canadian armies. Three women were members of the Army Nursing Corps.

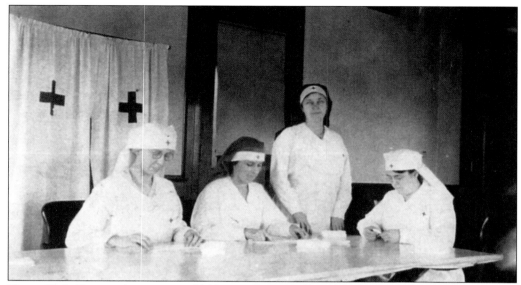

These Red Cross volunteers, c. 1918, are shown rolling bandages at the town hall. The volunteers, from left to right, are as follows: Miss Rose Doonan, Mrs. Bertha Cowan, Mrs. Oda Hollis, and Miss Alice Hanks.

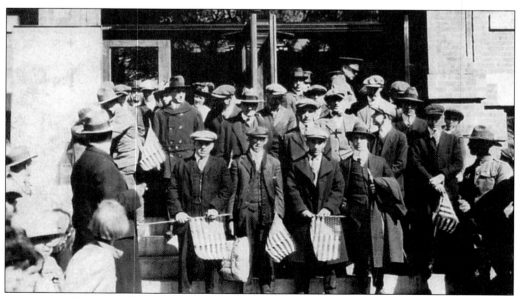

A group of South Hadley inductees stands before the town hall on their way to training on September 23, 1917.

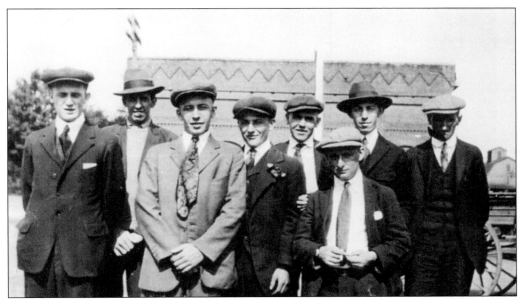

Boyhood chums, soon to be parted by the fortunes of war, on June 3, 1918, are pictured above. From left to right they are: Harry Holden, Wilfred Frenette, W.B. Frodyma, John Slattery, Alfred Peloquin, Lawrence Dudley, and Cecil Kenny.

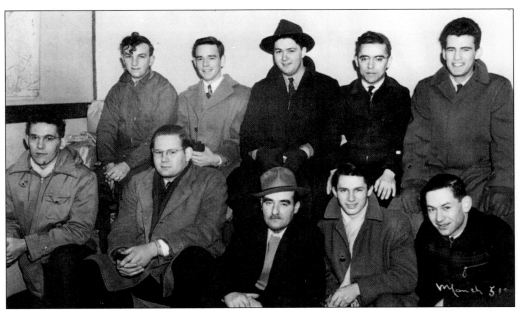

These are the inductees of WW II in 1942. These men, from left to right, are as follows: (front row) Ned Noel, Bloodgood, Sanderson, Dion, and Charette; (back row) Crossland, Colgan, Daviau, Provost, and Thayer.

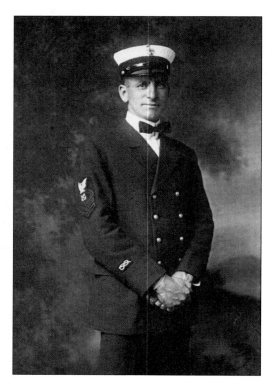

Chief Boatswains Mate John Mackenzie is claimed by both South Hadley and Holyoke as the only native son to receive the Congressional Medal of Honor. Mackenzie risked his life on December 17, 1917 by preventing a serious accident and probable loss of the *U.S.S. Remlik* and its crew. He grew up in South Hadley but after the war he married and ran a restaurant in Holyoke. He died of a heart attack in 1933.

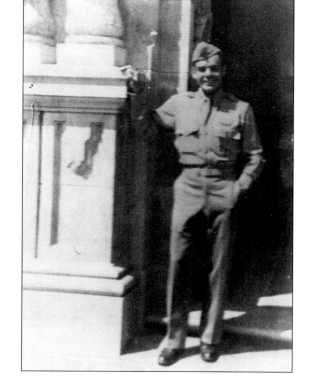

Lieutenant Rene Fournier was the first South Hadley resident to die in WW II. He was killed in the crash of an army bomber in September 1942 during a training flight near Spokane, Washington.

Mary Ryan, another South Hadley volunteer, served in the WAVES with distinction during WW II. She was one of the many women who served.

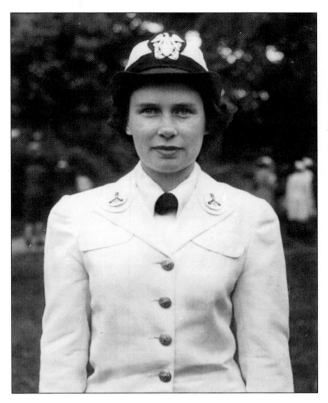

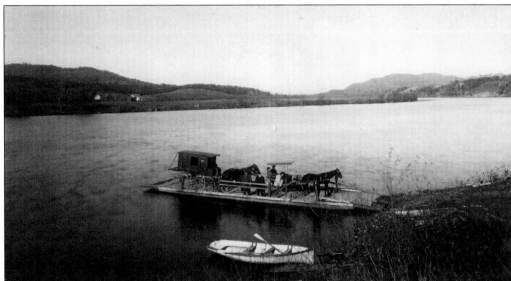

This is a northern view of the Connecticut River from the Smith's Ferry Landing which was located near where Brunelle's marina is now. Until the County Bridge was opened to traffic in 1872, South Hadley residents had to use this ferry or the swing ferry to cross the river to Holyoke. Smith's Ferry was established in 1770, and the first licensed ferryman was Elias Lyman. (Courtesy of Mount Holyoke College Archives and Special Collections.)

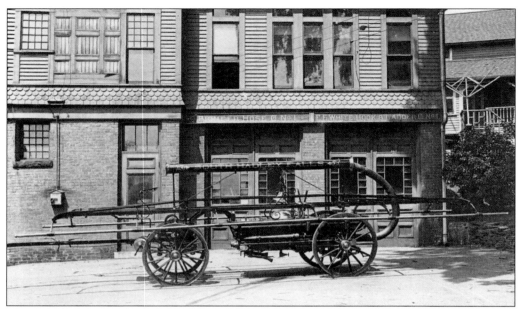

In 1845, the Town of South Hadley purchased a Waterman hand engine which was named Fountain Number 1, and Fountain Engine Company Number 1 was established to fight fires. The engine was used to fight fires and was entered in musters and won many prizes. The engine participated in South Hadley's sesquicentennial and bicentennial celebrations in 1903 and 1953. It is on permanent exhibit at the Old Firehouse Museum.

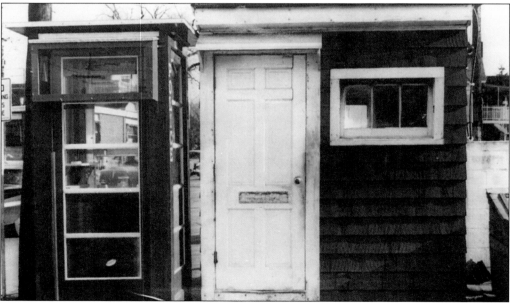

A familiar sight at the corner of Bridge and Main Streets from about 1945 until 1965 was this small booth that served as a police substation. It served as the night communications center for the police department, which did not have 24-hour service, as did the station on Pleasant Street. The telephone booth was removed and the phone moved into the booth that also contained a radio, intercom, two bank alarms, and a desk.

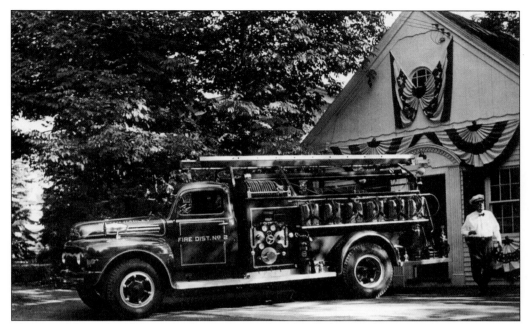

This wood-frame building on Park Street served as the firehouse of Fire District #2 from 1909 until 1963 when the new fire station was built on Woodbridge Street. Destruction of the Mount Holyoke Seminary building by fire in 1896 led to the formation of a committee which organized the district and the Fire Department in 1909 with Henry Bates as chief. The members of the committee were E.M. Burnett, W.A. Burnett, C.A. Gridley, J.C. Mellen, and A.L. Wright.

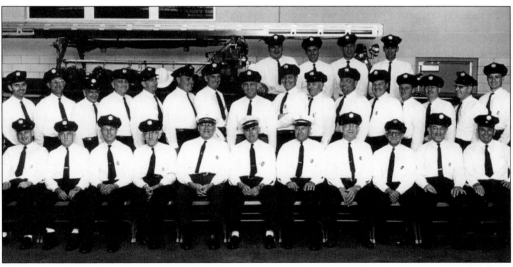

These are the volunteers and chiefs of Fire District #2 in 1963. The volunteers, from left to right, are as follows: Croke, Lyman, Canney, Thornton, Deputy Chief Otto Kohler, Chief Erry Burnette Jr., Deputy Chief Earl Lyman, Bloodgood, Cox, Sidney Croke, and Bagg; (second row) Barry, Carey, Toye, Frank, Calkins, McAvoy, Warner, Ellison, Tower, Brockway, Stalmann, Crossland, Cleary, Volkman, Warren Carey, and Brooksbank; (back row) Sebastyanski, Chaffee, Thornton, and Keyes.

The Leaping Well Reservoir, together with Buttery Brook Reservoir, was once the source of water for the Fire District #1 area. Leaping Well Reservoir was built in 1892 at Leaping Well Brook but, in time, demand outgrew the capacity of the two reservoirs. In 1951, a contract to buy Quabbin water was negotiated, and the reservoirs were phased out.

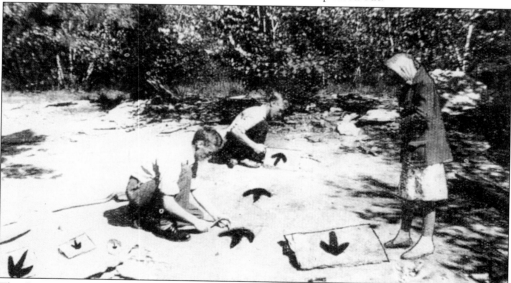

The Connecticut Valley is a good place to observe dinosaur tracks preserved in shaley sandstone. The first specimen was found in 1802 by Pliny Moody while plowing on his father's farm at Moody corner. Thousands of specimens have been found throughout the Connecticut Valley. In 1933, Carlton Nash of South Hadley discovered a deposit of footprints that he and his family mined and sold in a museum/souvenir shop.

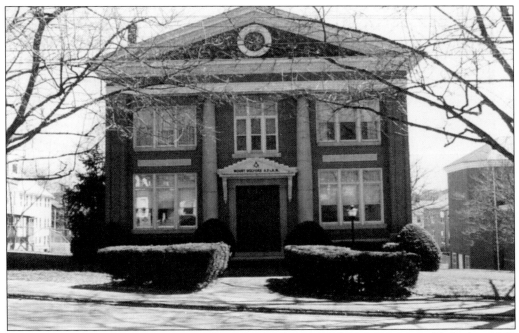

The Mount Holyoke Lodge of the Ancient Free and Accepted Masons was established in 1869 with a membership of 20. At first the Lodge met in rented halls. The membership grew and a desire for better quarters led to acquisition of land next to the Congregational church on North Main Street. The cornerstone for the present Temple was laid on September 26, 1914 during impressive ceremonies performed by the Grand Lodge of Massachusetts.

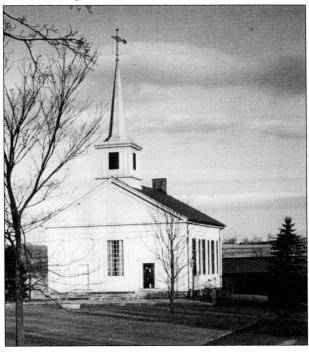

The Skinner Museum on Woodbridge Street began as the First Congregational Church of Prescott, Massachusetts, in 1846. In 1930, when Prescott was condemned to be flooded as part of the Quabbin Reservoir, Joseph Skinner bought the church and had it moved and rebuilt on Woodbridge Street. The larger part of the collection consists of early American artifacts, but also includes a sizable collection of minerals and shells and articles from foreign countries.(Courtesy of Mount Holyoke College Archives and Special Collections.)

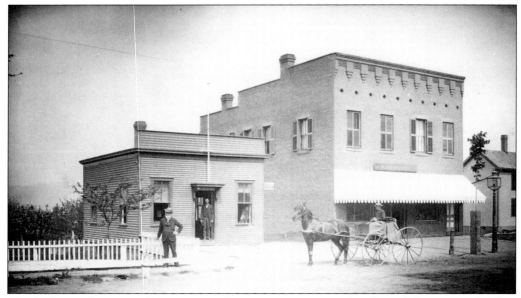

The little wooden post office opposite the town common was burglarized five times, the first time in 1891 and the fifth time in 1906. The thieves did not get much the first time, nothing the second and third times, but nearly $1,000 in 1903 and $9.30 in 1906. In 1907, the Glesmanns built a brick building next to their drugstore that they leased for a post office.

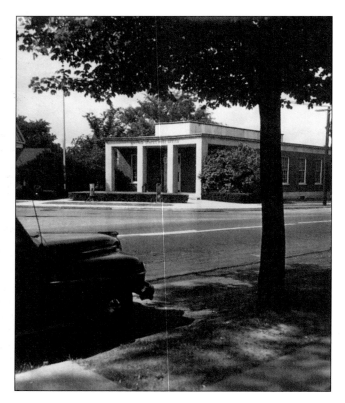

The present post office was built by the WPA in 1939 and dedicated in September 1940. Before that, a brick building built in 1907 next to Glesmann's drugstore had been leased to serve as the post office and before that a little wooden building. (Courtesy of Mount Holyoke College Archives and Special Collections.)

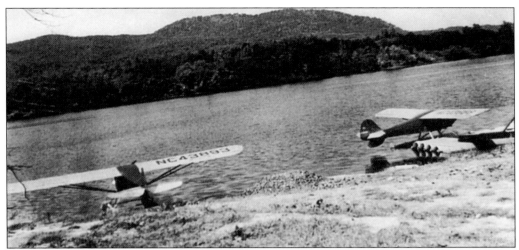

The Mount Holyoke School of Aeronautics was based on the Connecticut River in 1945 and 1946. Brothers Stanley and Fred Haber, WW II pilots, offered classes in pilot training as well as rides around the area. A ride to Quabbin was $5. One loop in the sky was $1.50. The seaplanes were based on Alvord Street next to Brunelle's Marina. (Courtesy of Porter Burns Sr.)

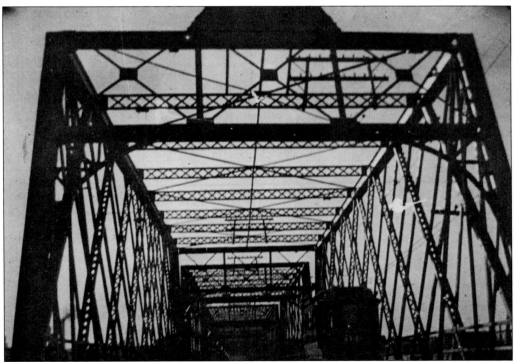

The Old County Bridge was built in 1872 because ferries could not handle the increasing traffic between South Hadley and Holyoke. The bridge soon became inadequate as traffic continued to grow. A new bridge 18 feet wider was built around the old one and completed in 1890. Although repairs and improvements were made over the years, the bridge deteriorated and became inadequate, and has been replaced by a larger, stronger one.

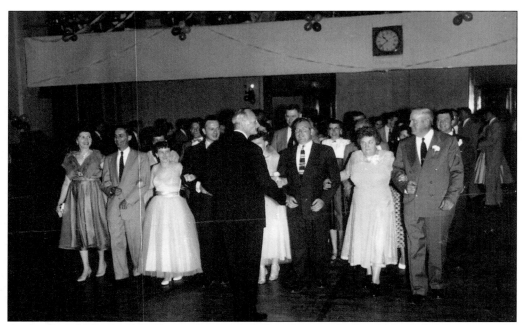

At the Grand March of the First Policeman's Ball at the town hall in 1954, Bill O'Brien was the choreographer. In the first row from left to right are the Ballards, Dunphys, Lawlers, and Popps. (Courtesy of Henry Decker.)

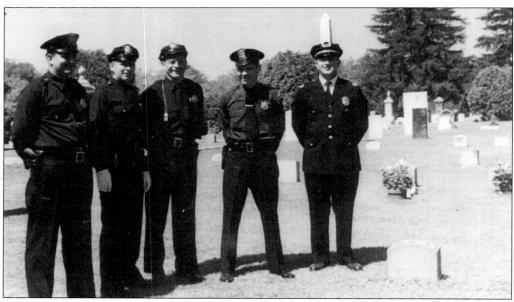

Police officers at the Evergreen Cemetery on Memorial Day in 1957, are pictured here. The officers are from left to right: Henry Decker, Roger Perreault, Paul Lebeau, Robert Taylor, and Deputy Chief Pat Mahan. (Courtesy of Henry Decker.)

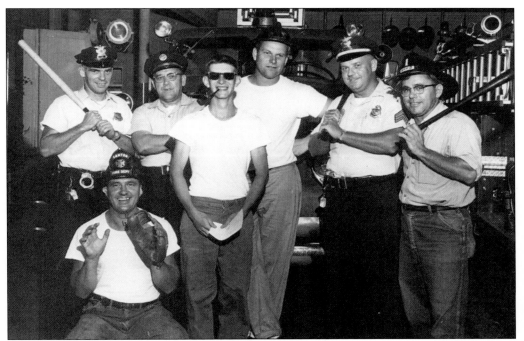

The firemen and police prepare to do battle for the Jimmy Fund. Pictured from left to right are: Charles Allard (kneeling), Robert Taylor, Harold Brooks, Greg Komer, Rudy Wojnarowski, Henry Decker, and Paul Robillard.

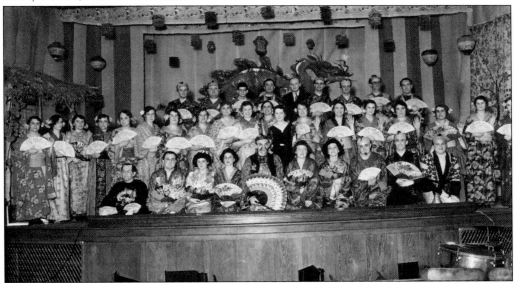

The Brotherhood of the Congregational Church of South Hadley Falls presented the *Mikado* on April 21 and 22, 1932 at the town hall. Among well-known town residents who served in the cast and/or on committees were: Reginald Carey, James Allen, William Lamb, Evelyn Smith, Bessie Brainerd, Lillian Webster, Bertha Cowan, Kathleen Brockway, Charles Scott, Alice M. Scott, Avel Lane, F. Herbert Webster, Frederick Roberts, Fred Bailey, Byron Hudson, June Warfel, and Marion Smith.

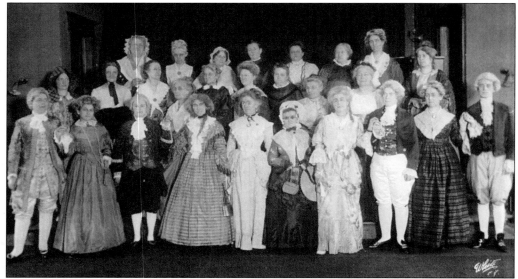

The Daughters of the American Revolution, Dolly Woodbridge Chapter, presented the play *Presidents' Wives* in February of 1922 at the Odd Fellows Hall in South Hadley.

The youth group of the Congregational Church of South Hadley Falls are preparing snacks for their meeting. They are Trudy Scheinost, Jonathan Holly, William Ryder, Jane Follet, and Lois Scheinost. (Courtesy of the Congregational Church of South Hadley Falls.)

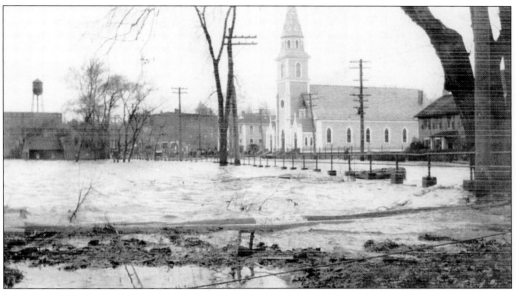

During the 1927 flood the water overflowed onto Main Street.

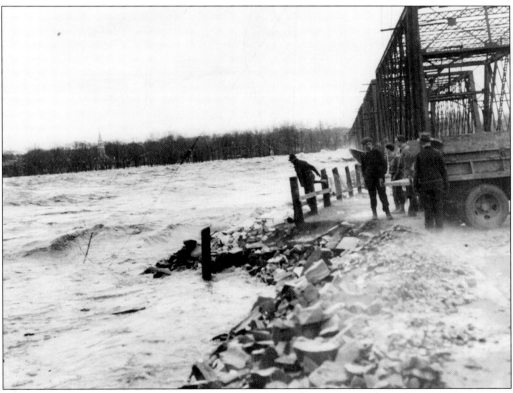

One of the worst floods of the Connecticut River in this area was that of 1927. This view is taken from the Holyoke side. Saint Patrick's Church steeple can be seen above the trees.

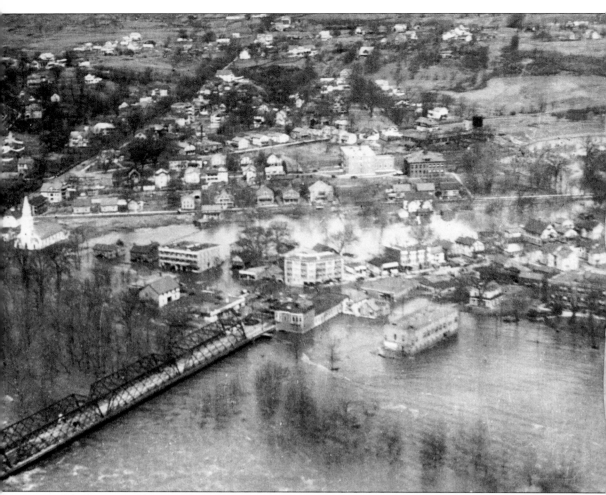

This is an aerial view of South Hadley during the 1936 flood. It is considered the worst flood in the history of the town with over 16 feet of water going over the dam. The Old County Bridge had to be closed as it was immersed in water and battered by huge blocks of ice. People were evacuated from their homes in the area of Main, Bridge, and School Streets.

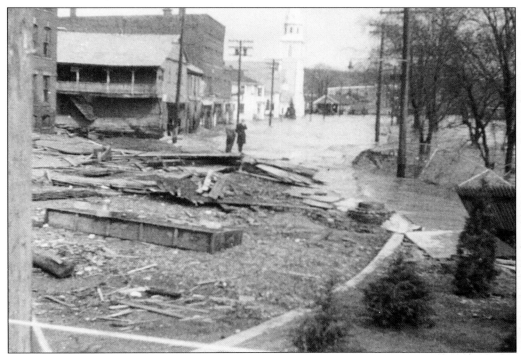

This view of Main Street from North Main Street during the 1936 flood shows the damage to the stores. Their interiors were completely destroyed. Saint Patrick's Church and rectory and the buildings beyond are still inundated.

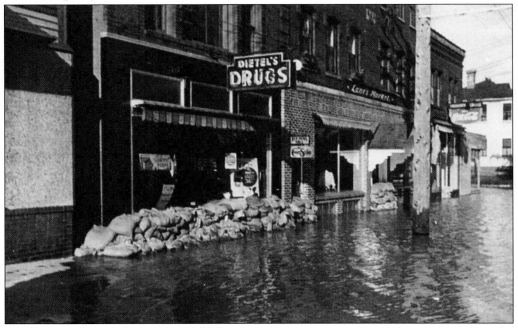

Sandbags were used during the 1936 flood in an attempt to protect the stores against the flood waters.

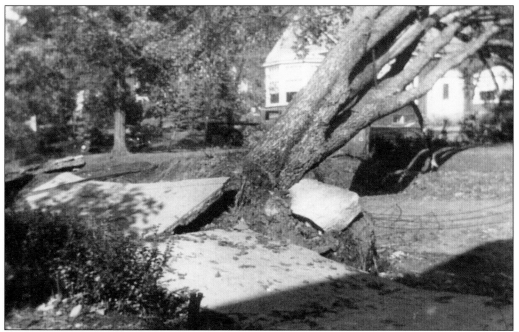

The 1938 hurricane caused a tremendous amount of damage all over town. Many buildings and trees were demolished or badly damaged. The greatest loss was at Mount Holyoke College where two hundred trees on campus and one thousand on Prospect Hill were blown down. In the Falls area most of the trees in Lamb's Grove were uprooted, many over one hundred years old.

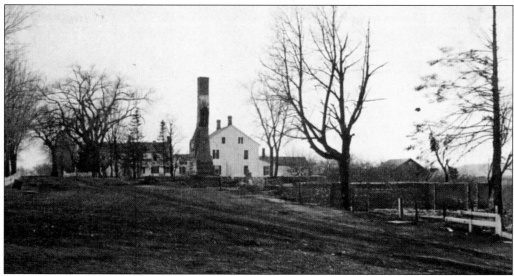

One of South Hadley's worst fires took place Sunday, April 2, 1876 on the west side of College Street in the Center. The hotel, hotel barn, Spooner's meat market, stage office, Gridley's store, small post office, and several other buildings were destroyed. The buildings were wooden, and fire engines had to be summoned by messenger from the Falls and Holyoke. All that could be done was keep the fire from spreading.

Six

CENTENNIALS

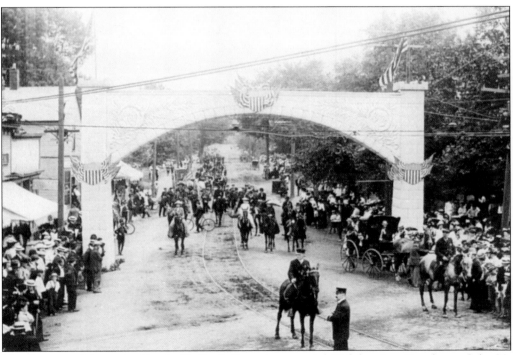

Marchers participate in South Hadley's Sesquicentennial Celebration Parade on July 30, 1903 as they pass under an arch erected for the occasion near the intersection of Main and Bridge Streets.

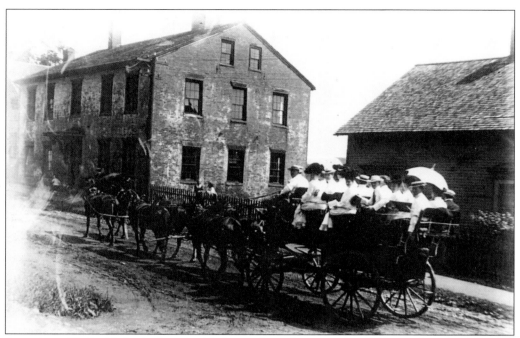

A carriage filled with festively attired ladies and gentlemen in the 1903 parade passes the "Old Brick Chapel" on North Main Street.

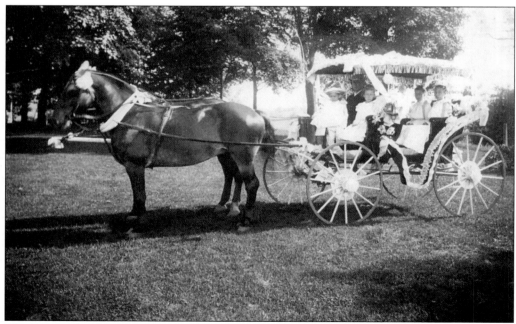

The Lyman family carriage that participated in the 150th Anniversary Parade included John Lyman, at the reins, accompanied by Hiram, Helen, Alice, and Ruth Lyman.

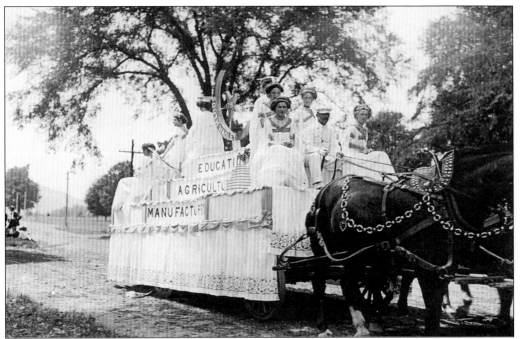

This is one of the South Hadley floats entered in Old Hadley's celebration in 1909. Beulah Scott, daughter of Charles and Angelina Scott, is at the right of the driver. The float represented the town seal with its motto of "Education, Agriculture and Manufactures."

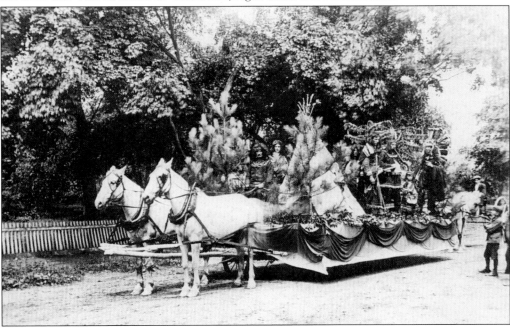

This Indian float in the Sesquicentennial was operated by Redcliffe Canoe Club members. Among those on the float were: Dr. Harold W. Lamb, Dr. Howard Smith, Ed Harris, and Thomas Skinner.

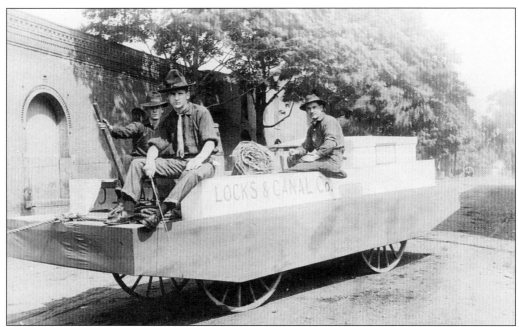

A float in the sesquicentennial parade represented the flat boat used on the South Hadley Canal to bypass the rapids.

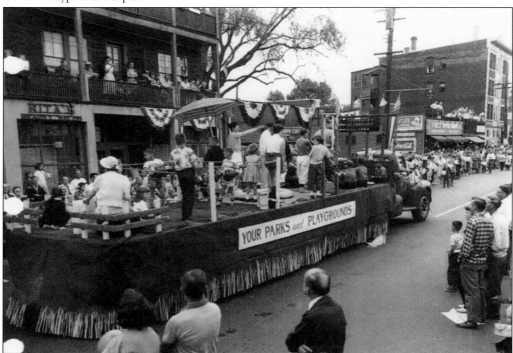

The South Hadley Parks and Playgrounds float was also a part of the 1953 celebration. The girl with the outstretched arm, under the umbrella on the float, is Elinor Jones, class of 1954, South Hadley High School.

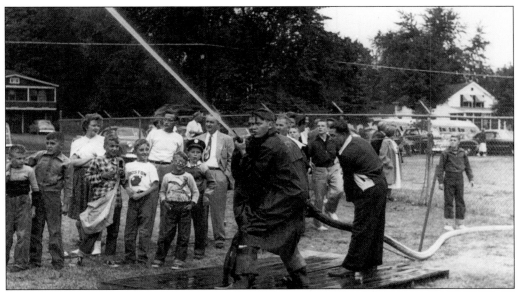

A Firemen's Muster was part of the 1953 festivities. A portion of the competition was to see which fire company could shoot water the farthest from a hand-operated pumper.

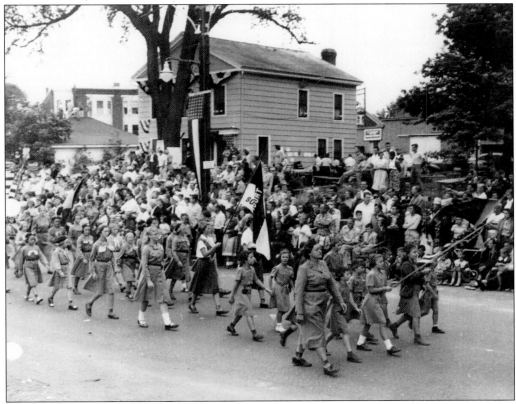

A large contingency of girl scouts and brownies are marching by the Knights of Columbus building on Main Street during the bicentennial parade.

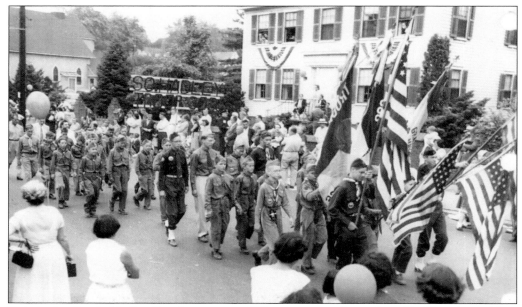

This is the South Hadley Boy Scout troop 302 just passing Saint Patrick's Church on Main Street in the bicentennial parade.

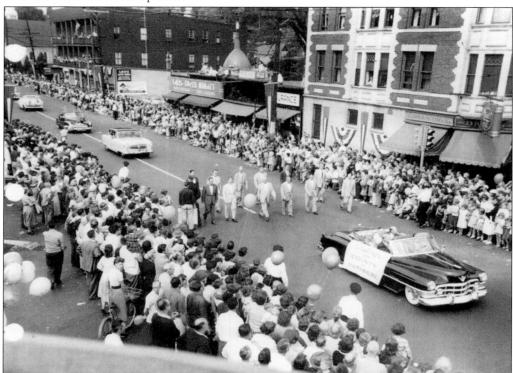

Among the town officials passing down Main Street were: Huey McKay, Ernest Noel, Gerald Lawler, Owen Dunphy, and Mr. Hollis. Beside the large turnout of townspeople lining the streets, many others were on porches, in windows, and even on rooftops.

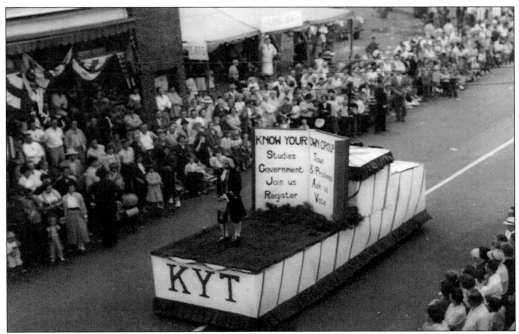

This was the float of Know Your Town (K.Y.T.), a newly formed group encouraging all to study their town government and register to vote.

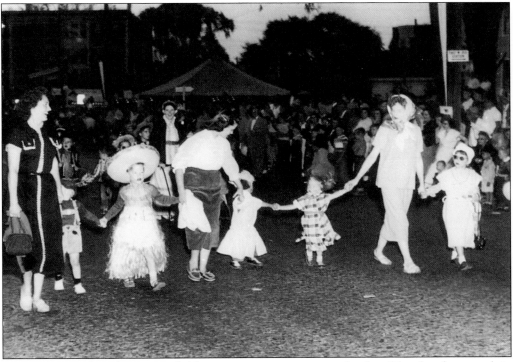

This is a group of much younger children in costume appearing rather bewildered as they march in the 1953 bicentennial parade. Perhaps you can identify them, or maybe you are one of them.

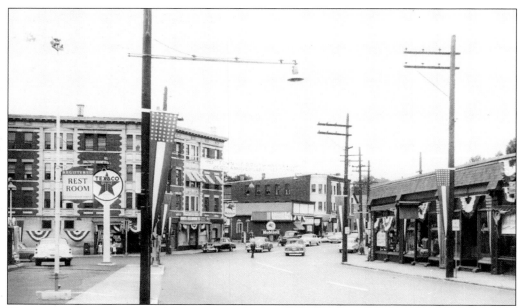

This picture depicts stores and businesses on Bridge and Main Streets as they appeared decorated for the town's bicentennial in 1953.

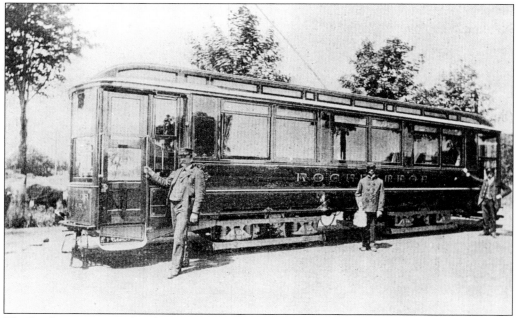

The Rockrimmom was the elegant Springfield Street Railway parlor car which carried President William McKinley and his party to South Hadley Center to attend commencement exercises at Mount Hoyloke College June 20 and 22, 1899. It also carried Massachusetts Governor John Bates in 1903 to attend South Hadley's sesquicentennial celebration. The car, with its luxuriously furnished interior, provided palace-car transport for notables, wedding parties, and special social events for about 20 years. (Courtesy of Mount Holyoke College Archives and Special Collections.)

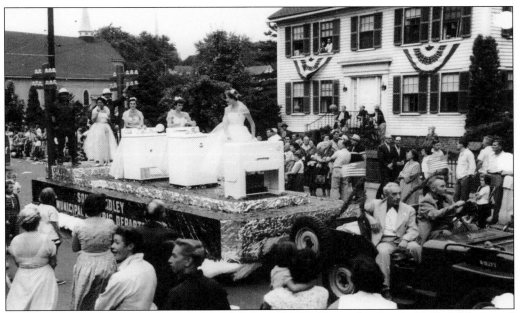

The latest electrical equipment for the home is displayed on the South Hadley Municipal Electric Department float at the 1953 parade. Standing behind the dryer is Marilyn Green (Mrs. Allan Simpson).

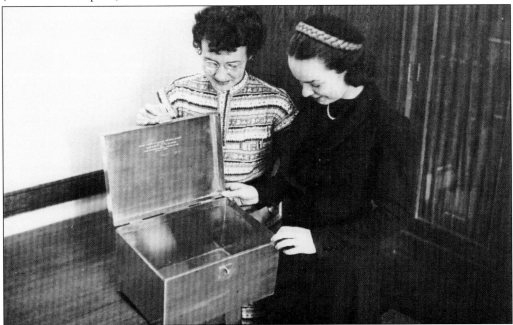

Rosamond Frame of Auburndale and Frances Clark of Korea inspect the Centenary box that will hold a prophecy of the year 2037. History students have drawn up a composite picture of the future American civilization to be placed in the vault of Williston Memorial Library until the college's bicentennial. (Courtesy of Mount Holyoke College Archives and Special Collections.)

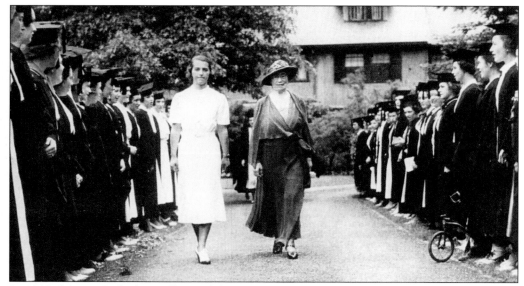

In 1937, Mount Holyoke College celebrated the centennial of its founding by Mary Lyon in 1837. In the photograph, President Mary E. Woolley is being led by a student escort to her last chapel service. She retired in 1937. Centennial exercises were held May 7 and 8 and included special chapel services, a symposium, play, garden party, reception, exhibits, and dance cycle. (Courtesy of Mount Holyoke College Archives and Special Collections.)

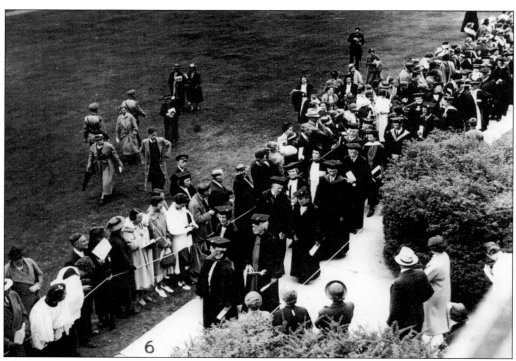

The Mount Holyoke College faculty and distinguished guests are processing to the proceedings. (Courtesy of Mount Holyoke College Archives and Special Collections.)

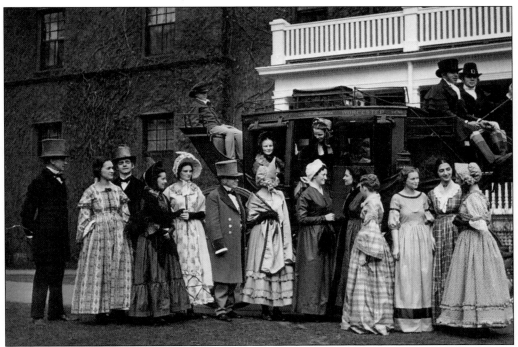

As part of the centenary celebration, students presented an historical pantomime, *Mount Holyoke Opens*, which was presented May 7 in front of Brigham Hall on the campus. In this scene seminary students are being greeted as they arrive by stagecoach to attend the seminary. (Courtesy of Mount Holyoke College Archives and Special Collections.)

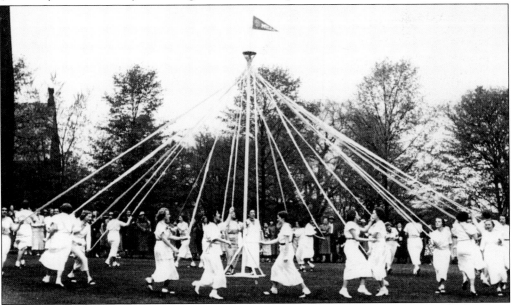

Among the centenary festivities was the student frolic May 7 during which students danced around three maypoles while kiltie-clad bag-pipers piped gay tunes. (Courtesy of Mount Holyoke College Archives and Special Collections.)

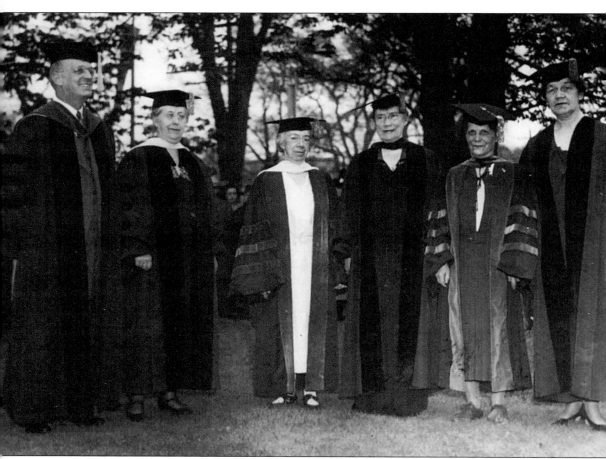

Among the special guests invited to the centenary observance were representatives of Mount Holyoke College's sister colleges. These included President Ralph Hickok (Western College), President Vivian B. Small (Lake Erie College), Professor Emeritus Florence Snell (Huguenot University, South Africa), Miss Caridad Rodriguez (International Institute for Girls, Spain), and President Aurelia Reinhardt (Mills College). President Woolley of Mount Holyoke College is the fourth from the left in the photograph. (Courtesy of Mount Holyoke College Archives and Special Collections.)

Seven

ORGANIZATIONS, SPORTS, RECREATION

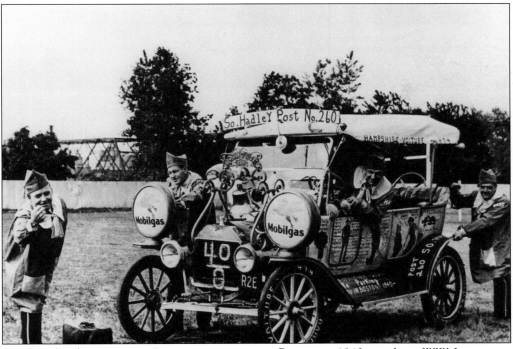

Heading for the American Legion convention in Boston in 1940 are these WW I veterans, members of Post 260. From left to right are: Bert Goss, Eugene Orsini, Driver Fran Dressell, and Bill Goodwin. The 40/8 on the radiator stood for the capacity of the French railroad cars, 40 men or 8 horses. Note the "sea wall" in the background erected after the flood of 1936. (Courtesy of Shirley Goss Lewis.)

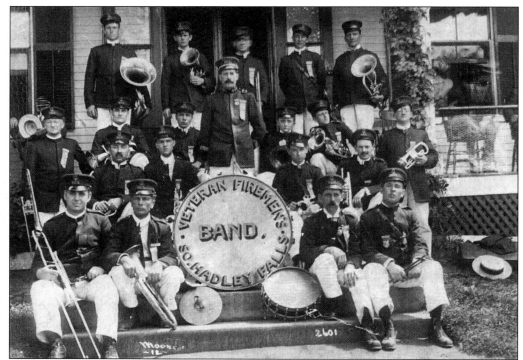

The Veteran Firemen's Band was part of the Fred M. Smith Veteran Firemen's Association. The band accompanied firemen to musters and played at balls, banquets, and many town festivities. During the 1890s and early decades of the 20th century, volunteer firefighters who could no longer do strenuous work formed veteran firemen's associations. The Fred M. Smith Veteran Firemen's Association was established on August 1, 1903.

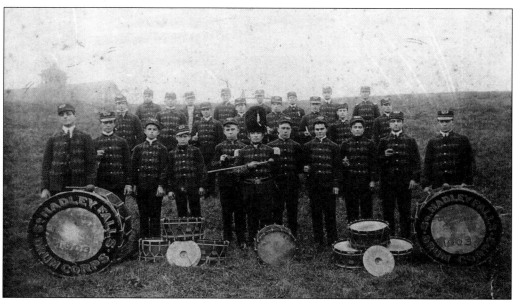

The South Hadley Drum Corps was founded on September 1, 1903.

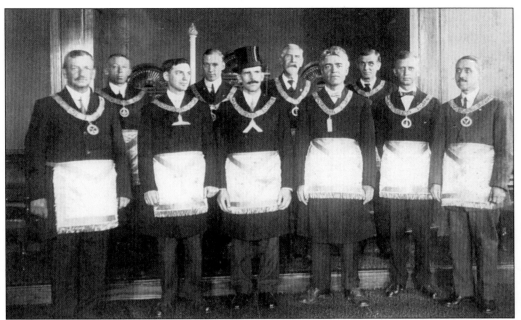

The officers of the 1925 Mount Holyoke Lodge of Masons are pictured from left to right as follows: (first row) treasurer (name unknown), William H. Downs (senior warden), David Glassford (master), Marine Cooper (junior warden), unidentified (junior steward), and Harrison E. Dunbar (secretary); (second row) Ralph N. Batchelor (senior deacon), unidentified (royston), James C. Weir (tyler), and Ray Scott (steward).

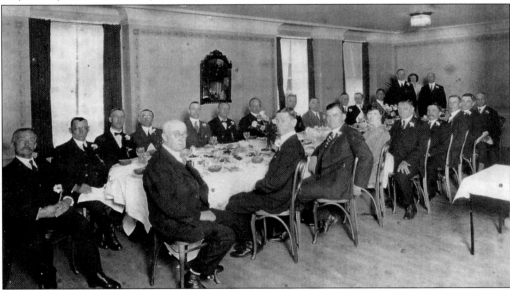

The South Hadley Center Men's Club was organized in the late 1930s with Elliott B. Lyman as president and Albert Patty as secretary-treasurer. Monthly meetings were held with outstanding speakers. An annual lawn party, that included games, square dancing, and a big supper, was held at the end of May on the town common to raise money for various projects. One of these was a community Christmas party for the town's children.

The South Hadley Women's Club was organized on March 24, 1898 by 12 women at the home of Frances G. Hill. The goals were to develop a higher moral and intellectual life among its members and promote the best interests of the community. The members have accomplished this through written papers and speakers on many topics. The members have carried out many projects to aid the community and worthy causes. Two scholarships are given each year.

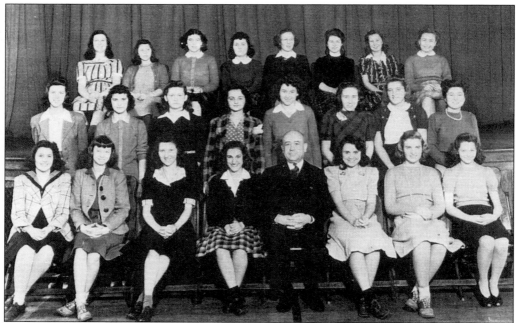

This is a photo of the Sixteen Girls Club at South Hadley High School in 1943. It was an extra curricular organization and constituted a portion of the South Hadley High School Glee Club. The name "Sixteen Girls" was chosen because transportation for only 16 could be provided. Under the leadership of Thomas Auld, this group entertained at school functions and also at functions of many outside organizations.

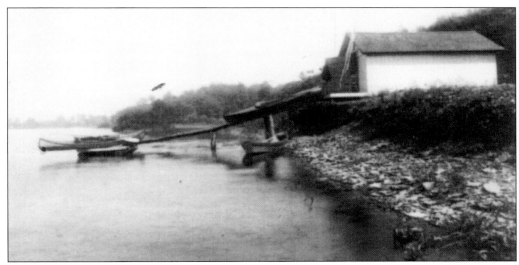

This was the first Redcliffe clubhouse. The Redcliffe Canoe Club on upper Canal Street was organized in 1889 and incorporated April 5, 1895. The club's name was taken from the red sandstone cliff on which the clubhouse stood. Among the early officers and charter members were Fred M. Smith, Louis Lamb, August Moos, August Hofmann, Charles Davenport Sr., Charles Davenport Jr., James, and William Lamb. (Courtesy of Redcliffe Canoe Club.)

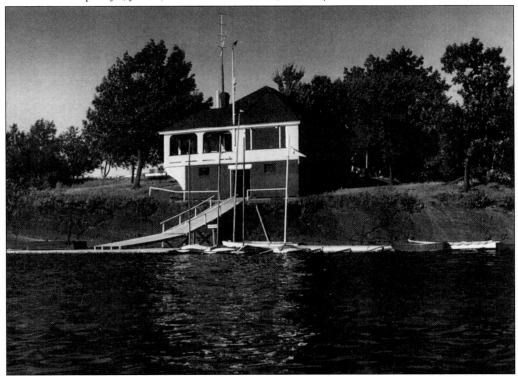

This is the current Redcliffe clubhouse. The first three clubhouses were destroyed by fire, but each time were rebuilt and improved. There are many social activities in addition to boat activities and swimming. (Courtesy of Redcliffe Canoe Club.)

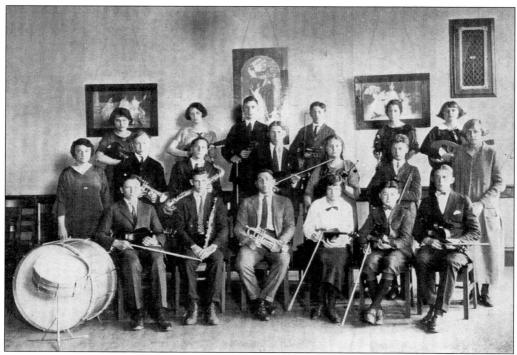

In this photograph of the South Hadley High School orchestra taken around 1925, Nellie Cross is in the second row at left. The orchestra played at all the socials at the school.

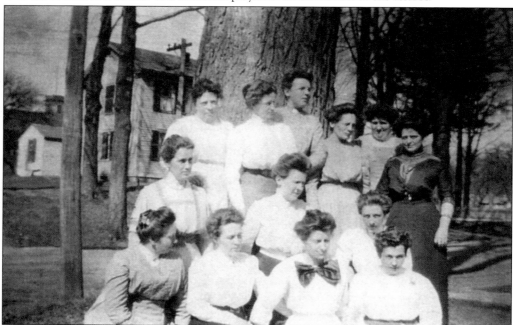

In this picture of the 500 Club, in the bottom row are Marian Wilkinson, Molly Burnett, Mrs. Lang, and Lola Bates Burnett. In the second row are Mrs. Asa Kinney, unidentified, and Mrs. Anson. In the third row, Mrs. Lovell is the fourth woman and Mrs. Alvord is the last one.

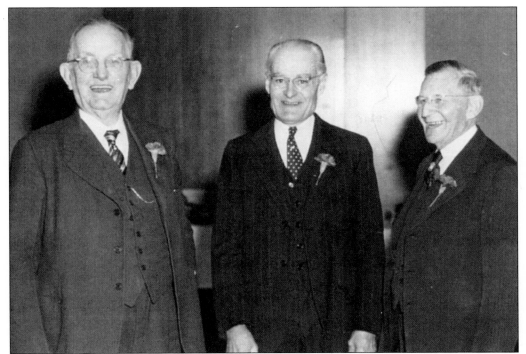

Shown receiving pins for 50 years of membership in the Pocumtuck Club are M.J. Moriarty, Wilfred W. L'Esperance, and Hugo Kaeppel. The club was organized on October 20, 1905 and was active as a social and charitable club. Other familiar names of members were George McDonnell, Hiram Chaffee, Wilfrid Scott, Sid Croke, Wayne Cordes, Larry Graham, Richard Bonneville, Michael Kozinetz, Myron W. Ryder, Alex Bannerman, Ernest Noel, Alfred Larose, Ed Glesmann, and Warren Carey.

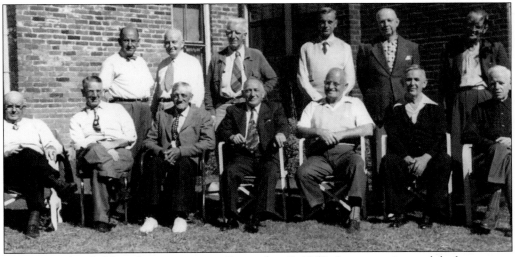

Camp Comfort held its first reunion on September 7, 1952. It was a private club that met at a camp on the cove in the canal area of the Connecticut River. Seated are: John Kennedy, Billy Johnston, Bill Sligo, John Albert Spencer, Billy Ford, Billy Smith, Frank Granfield, Jake Bertram, Ray Pettigrove, Bill Holgate, and Gene Stanley.

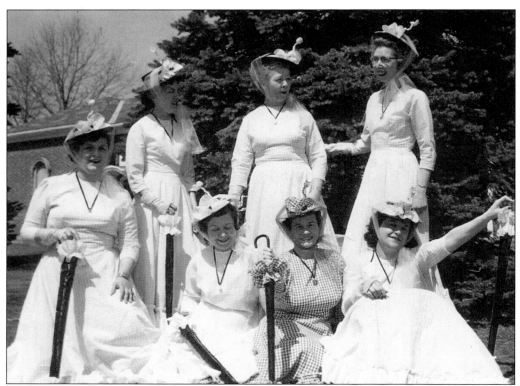

In the Gay Nineties Revue on April 20, 1955, the members of the Flora Dora number included Peggy Griffin, Mary Scodard, Marcelle Schenker, Marilyn Green, Claire Harrington, and Veronica LaFleur. They were teachers at the Woodlawn School. (Courtesy of Ruby Roberts.)

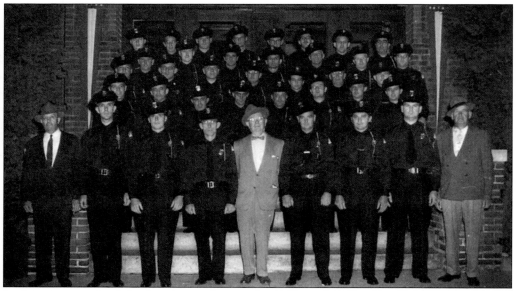

In this photograph of the Auxiliary police in the 1950s and 1960s, Chief John Sullivan is the first person in the first row, Maurice Fitzgerald is fifth, and Charles Popp is at the end.

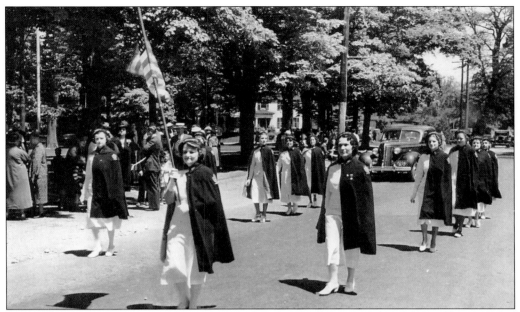

These ladies of the Legion Auxiliary are in the Memorial Day parade of the 1930s. Included are Jane Jubinville, Cora Blackmer, Cora Methot, Beatrice Hofmann, Amelia Reed, Doris Peloquin, and Irene Day.

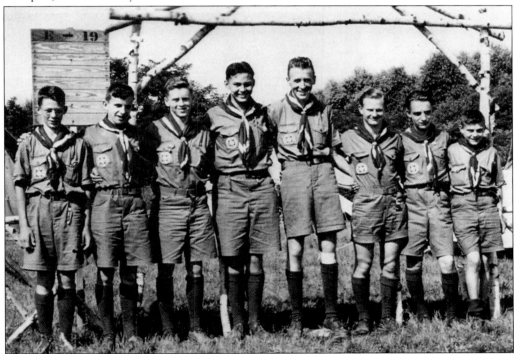

This photograph is of the Boy Scouts at camp about 1959. They are from left to right: Jack McCabe, Jim Whitcomb, Richard Scholl, unidentified, Gordy Boutilier, unidentified, Frank Rudert, and unidentified.

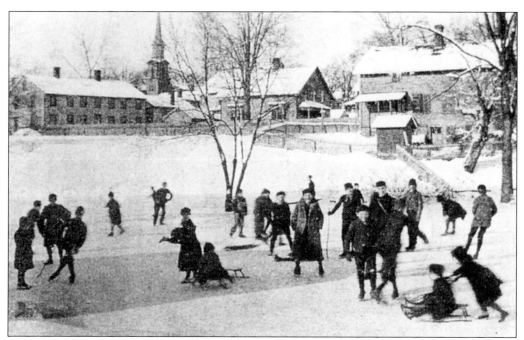

This view of people skating and sliding at the top of North Main Street was taken in 1892. (Courtesy of Bernie Blood.)

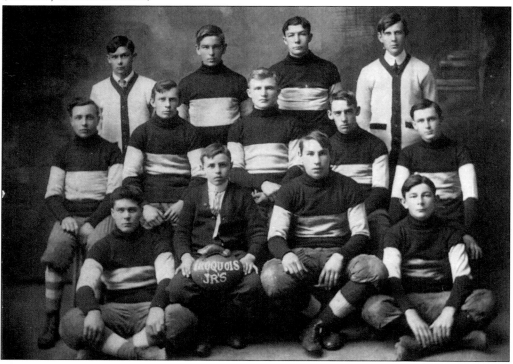

The Iroquois Juniors were the younger version of the Iroquois football team. This is a picture of the team about 1911.

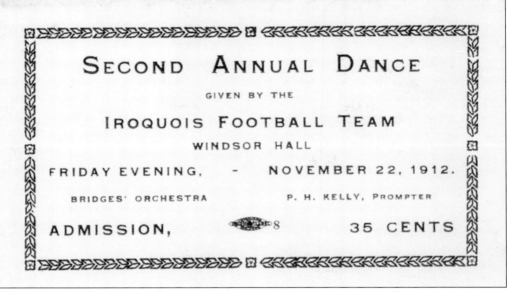

SECOND ANNUAL DANCE

GIVEN BY THE

IROQUOIS FOOTBALL TEAM

WINDSOR HALL

FRIDAY EVENING, - NOVEMBER 22, 1912.

BRIDGES' ORCHESTRA P. H. KELLY, PROMPTER

ADMISSION, 8 35 CENTS

This ticket was for the second annual dance given by the Iroquois football team, a town team, to help raise money for the team. The price of admission was 35¢, which included an orchestra! (Courtesy of William J. Poli.)

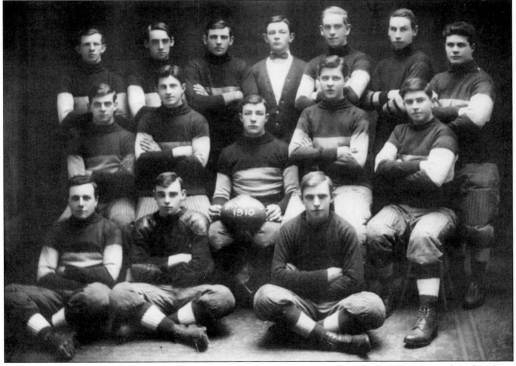

The Iroquois were the South Hadley football team connected with the Knights of Columbus. They played the Tanglefoots once a year to see which was the town team. The Iroquois died out for a while, tried to become active again, but petered out again.

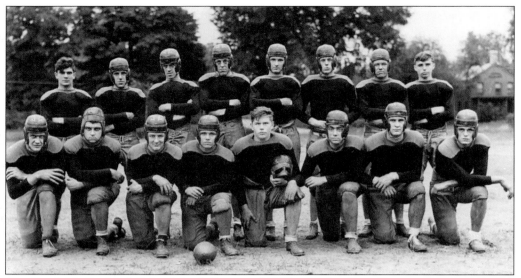

The South Hadley High School football team of 1937 were the Class Champions. Kneeling are: Foster Crooke, Howard Irwin, George Daviau, George Riverst, Mike Curtis, Edgar Quenneville, Chief Bradley, and Ray Smith. Standing are: Serge Orsini, Mike Polchlopek, Tim Sullivan, Calvin Reed, George Opalenik, Red Early, Roland Joniak, and Bill Jubinville. (Courtesy of William Jubinville.)

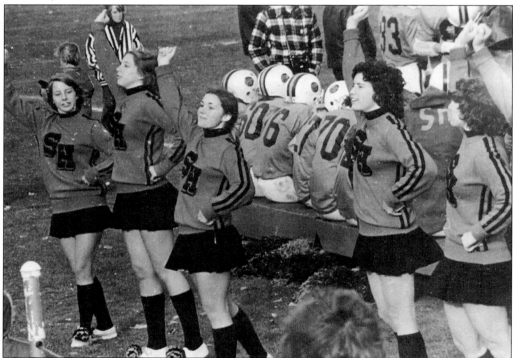

Cheering the South Hadley High School football team on to victory are, from left to right: Carol Colthart, Cathy Christopher, Linda Adams, Monica Nelen, and Barbara Ryder. (Courtesy of the Congregational Church of South Hadley Falls.)

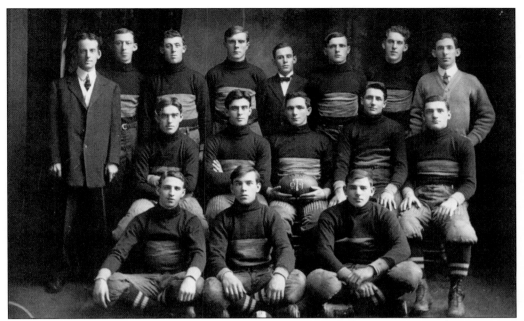

The Tanglefoots were one of the first South Hadley football town teams. The team was organized by Gene Clancy who acted as coach. Among their supporters were Police Chief John Sullivan and Dr. Ernest Noel. The team played teams from surrounding towns. They were western Massachusetts champions in 1908. There was a hiatus during WW I, but the team was active again in the late 1920s and early 1930s. (Courtesy of Henry Decker.)

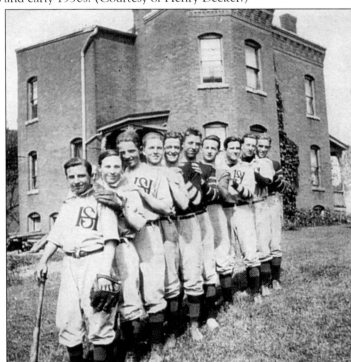

This is the 1920 South Hadley High School baseball team. From left to right are: Leon Noel, Herb William, Hall Ranger, Art Messam, James O'Connell, John Mitchell, John Quirk, Bill Corriden, Cappy Ranger, and Ray Lynch.

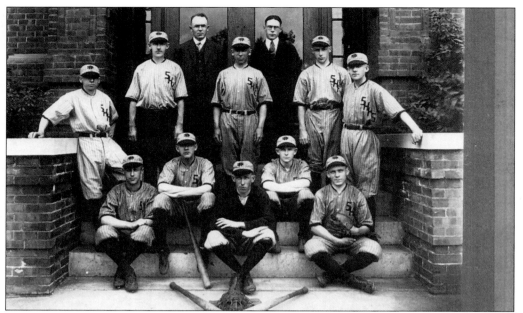

This is the South Hadley High School baseball team about 1918 or 1919. There were only 11 boys to pick from that year, so Coach Clancy and Captain Lydon had some difficulty in selecting the first team. Principal Whittemore is in the last row on the left.

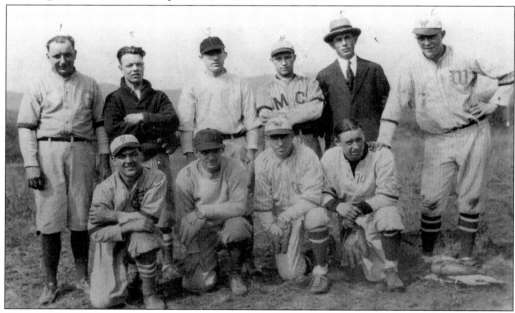

A town baseball team that was active in South Hadley Center during the early 1920s played on Charles Spooner's property on Silver Street. Spooner, who loved baseball, helped finance uniforms and equipment. Team members in the photograph, from left to right, are: (front row) Jim Peters, Herve Choiniere, Polly Wall, and Ray Roberts; (back row) James Shea, Ray Peters, Francis Duffy, Leo Labelle, Tom Quinlan (manager), and Joel Baine. (Courtesy of Ray Roberts.)

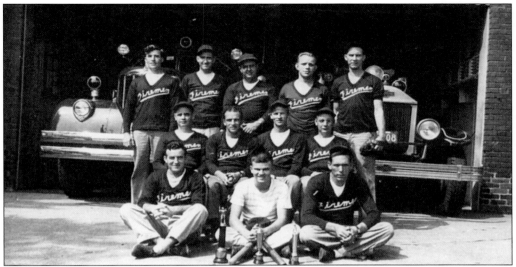

Pictured here in front of the firehouse on North Main Street are the baseball players representing the firemen's baseball team of the late 1950s. The players, from left to right, are as follows: (first row) Billy Moynahan, unidentified, and Cappy Griffin; (second row) Eddie Dunleavy, unidentified, Donald Hughes, and John Dunleavy; (third row) David Lewis, unidentified, Arthur Dubuc, Chet Marciniak, and Walter Wojnarowski. They had been town champions three years in a row, as the trophies in front indicate.

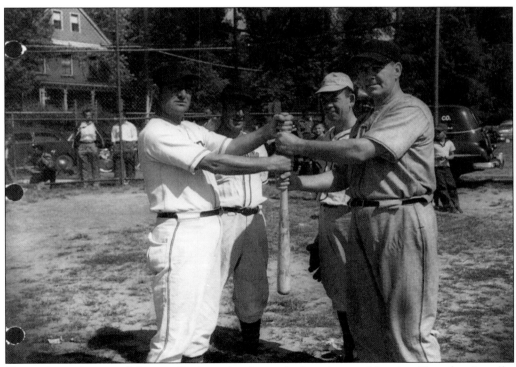

Shown here choosing " first ups" using a bat instead of a coin are: Maguire, Knowles, Lavelle, and O'Connor.

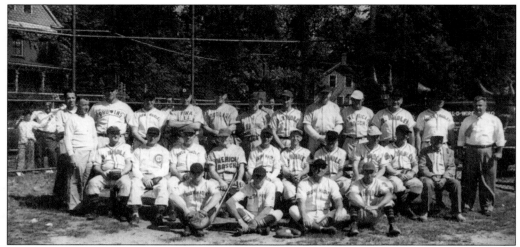

Players of the old timers baseball team of 1953 are shown posing at the Beachground. The players are from left to right: (front row) R. Perreault, R. Roberts, Ryan, and unidentified; (second row) S. Perchowski, J. Kelly, K. Stiles, F. Lizak, D. Reynolds, F. Lydon, W. Knowles, J. Lavelle, N. Fry, and E. Noel; (back row) F. Pula, A. Vanasse, R. Wojnarowski, O. Dunphy, H. Dressel, T. O'Conner, H. Miller, R. Landry, T. Long, unidentified, Y. Fry, C. Marciniak, and T. Landers.

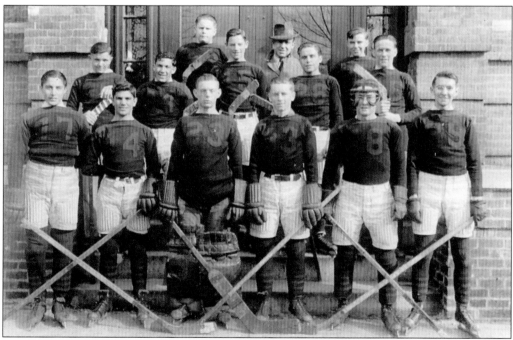

Members of the South Hadley High School hockey team of 1937 are pictured here. They are from left to right: (first row) Ray Beaudoin, Serge Orsini, Red Early, Jim Whitcomb, John Burnett, and Romeo "Pat" Girard; (second row) Howard "Moon" Everson, Leo Gagnon, and Dick Bonneville; (third row) Mike Curtis, Bill Bosworth (coach), and Bill Jubinville. (Courtesy of William Jubinville.)

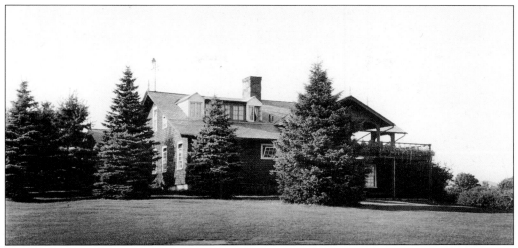

The Orchards golf course on Woodbridge Street is one of the finest championship golf courses in New England. It was built in 1922 by Joseph Skinner for his daughter Elisabeth, who became a top amateur golfer. It was designed and built by Donald Ross. A carriage house was moved to the site from one of his properties and became the clubhouse. It has been enlarged and renovated several times.

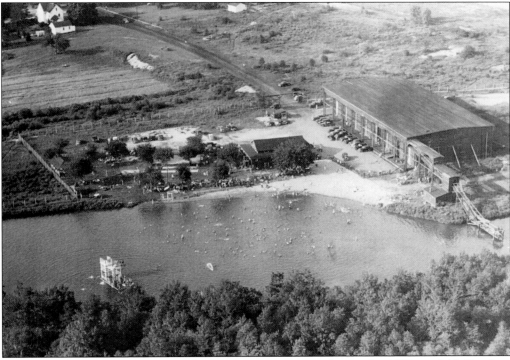

Hillside Bathing Beach was a popular local swimming spot during the 1930s and 1940s when the depression and war restricted travel. In 1935 Charles Lawrence transferred more than 13 acres to the Hillside Beach and Ice Company and developed the beach at the pond off the Granby Road. Note in the right-hand corner the icehouse with the ramp on which the blocks of ice were conveyed. In 1960, the property was sold to developers.

ACKNOWLEDGMENTS

Although the majority of the photographs in this book came from the collection of the South Hadley Historical Society, we would like to express our appreciation to the organizations and individuals who very graciously lent us material. We would especially like to thank Patricia Albright and Peter Carini of the Mount Holyoke College Archives and Special Collections for their assistance in locating and lending material. We would also like to thank Paul Graves and his colleagues at the Holyoke Room of the Holyoke Public Library for their assistance in making material available. We would like to express our appreciation to the following people who let us borrow their photographs: Mrs. Barbara Baran, Christopher Bascom, Bernie Blood, Geri Brockway, Mrs. and Mrs. Raymond Burke, Porter Burns Sr., the Congregational Church of South Hadley Falls, Ray D'Addario, Henry Decker, Daniel Ducharme, Helen Hamel, Agnes Everson, William Jubinville, Eleanor Klepacki, Stephen Lamb, Shirley Goss Lewis, Frank Jesionowski, Marion Lippman, Cynthia Long, Margaret Bain McDonald, Mount Holyoke College Art Museum, Mark Mueller, William Poli, Ray Roberts, Ruby Roberts, Paul Robillard, Richard Scott, Eleanor Small, Henry Smith, Janet Smith, Eunice Watts, and Frank Wotton. Ruth Ryder is to be commended for her dedication and hard work in typing the entries and seeing that everything was in place, Irene Cronin for researching historical facts, and Phyllis Bannerman for patiently helping to locate pictures and information.

The members of the committee of the South Hadley Historical Society who were responsible for selecting the photographs and compiling the book are: Ruth Ryder (Chair), Phyllis Bannerman, Irene Cronin, Brenda Griffin, Edgar Noel, William Schenker, and Josephine Wojnarowski